Audrey Flack

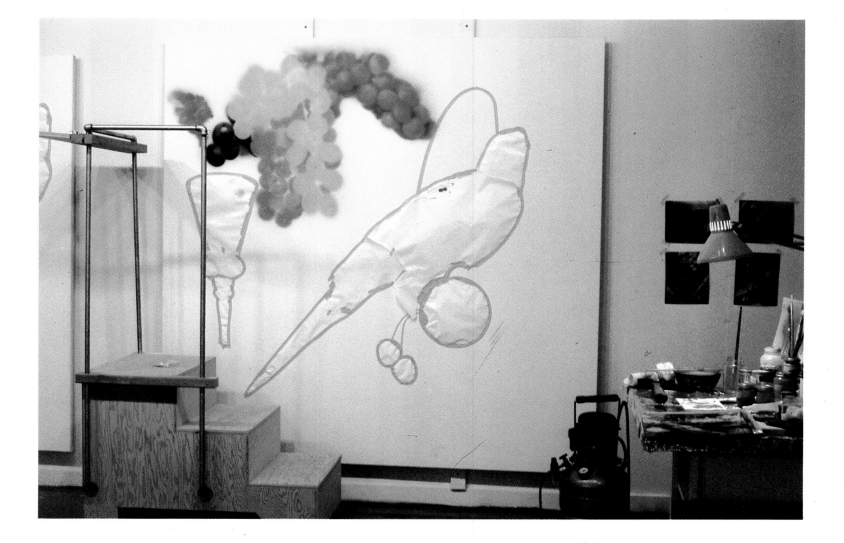

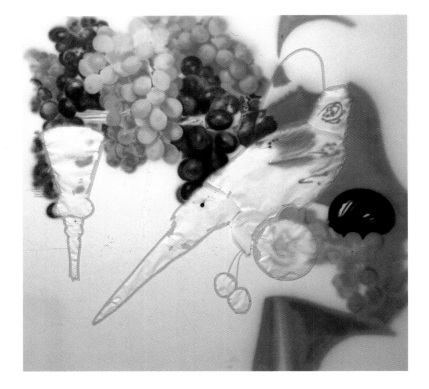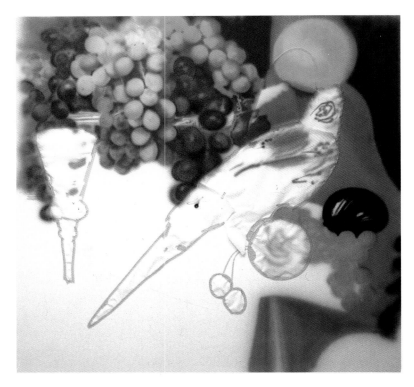

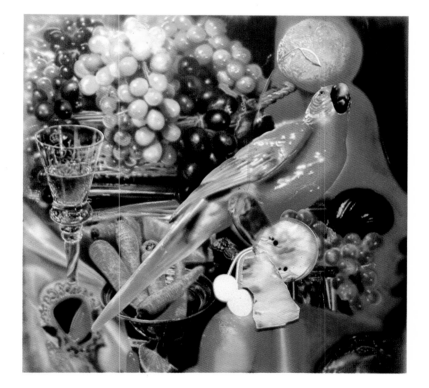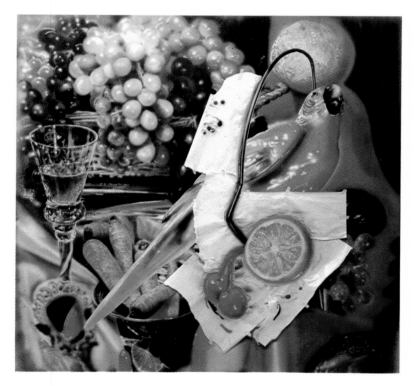

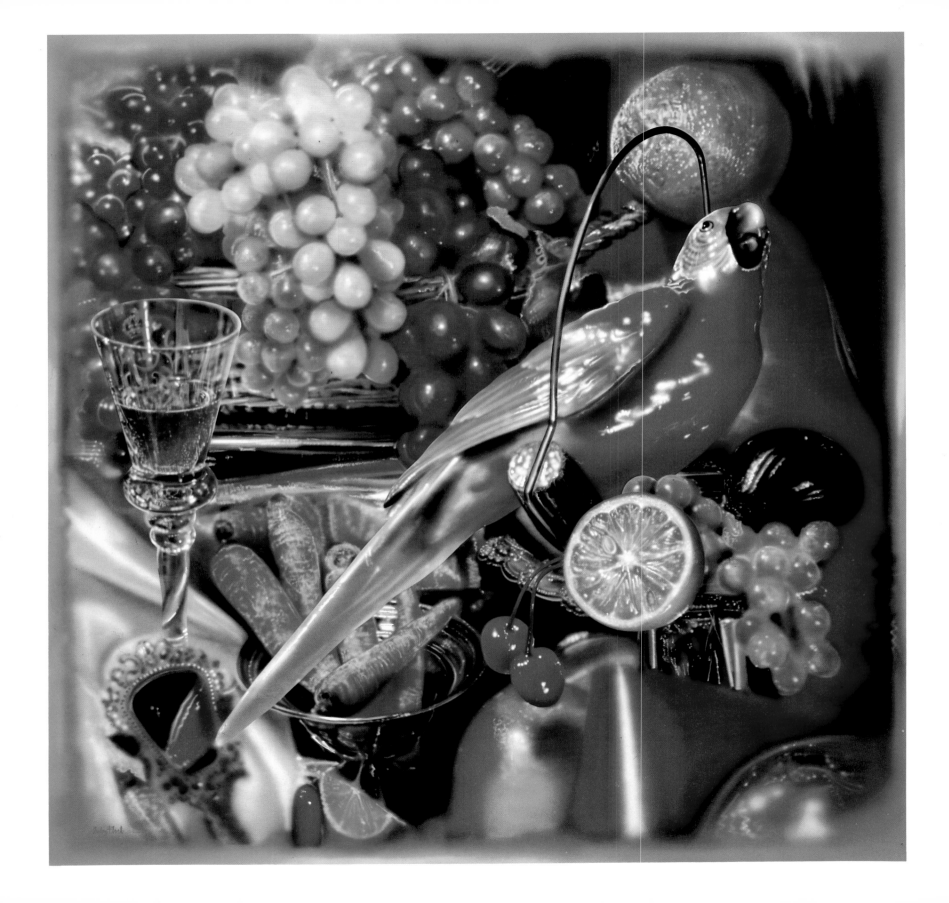

Introduction by Lawrence Alloway

Audrey Flack

ON PAINTING

HARRY N. ABRAMS, INC., PUBLISHERS, NEW YORK

For Bob, and for all our children

Second Printing, 1985

Editor: Margaret L. Kaplan
Assistant Editor: Jeanne Hamilton
Designer: Wei-Wen Chang
Bibliography and Chronology by Helene Zucker Seeman
Jacket photograph by Nancy Rica Schiff

Library of Congress Cataloging in Publication Data

Flack, Audrey.
 Audrey Flack on painting.

 1. Flack, Audrey. 2. Photo-realism—United
States. I. Title.
ND237.F46A4 1980 759.13 80-20603
ISBN 0-8109-0915-4
ISBN 0-8109-2235-5 (pbk.)

Library of Congress Catalog Card Number: 80-20603

p. 78 Reprinted from *Polish Jews* by permission of Sylvia Heschel and
 Schocken Books, Inc. Copyright 1947, renewed 1975.

p. 86 From *Marilyn* by Norman Mailer. Copyright 1973 by
 Norman Mailer and Alskog, Inc. All rights reserved.
 By permission of Grosset & Dunlap, Inc.

p. 90 Dylan Thomas: *Poems of Dylan Thomas.*
 Copyright 1952 by Dylan Thomas. Reprinted by permission of
 New Directions Publishing Corporation.

Illustrations © 1981 Audrey Flack

Published in 1981 by Harry N. Abrams, Incorporated, New York
All rights reserved. No part of the contents of this book may be
reproduced without the written permission of the publishers

Printed and bound in Japan

Contents

11. The artist with her parrot,
Albert Einstein Bierstadt

A Personal View

by Ann Sutherland Harris

I always wanted to draw realistically. For me art is a continuous discovery into reality, an exploration of visual data which has been going on for centuries, each artist contributing to the next generation's advancement. I wanted to go a step further and extend the boundaries. I also believe people have a deep need to understand their world and that art clarifies reality for them.

Audrey Flack in an interview with Cindy Nemser, *Art Talk,* Charles Scribner's Sons, New York, 1974.

The first work by Audrey Flack I saw was *Jolie Madame,* dominating its gallery at the New York Cultural Center in 1973. It was a large, glowing, richly colored, spectacularly realistic panorama of sparkling jewelry, glass, silver, and porcelain strewn across a polished surface. I was impressed but not sure what to make of such extravagantly original imagery. I backed off, reminding myself that I love Johann Sebastian Bach, Nicolas Poussin, Giorgio Morandi, and Lapsang Souchong tea, and forgetting momentarily that I also love Giovanni Lorenzo Bernini, Richard Wagner, fireworks, and curry. The following spring in Philadelphia, in another ambitious show of work by women artists, I saw two more paintings by Flack—a view of the baptistery of Pisa that looked like a gigantic blowup of a cheap color postcard, and *La Macarena Esperanza,* the Baroque Madonna by Luisa Roldán whose weeping face brings comfort to thousands of pilgrims in Seville, and each image was unforgettable, disturbingly so. The variety of Flack's subject matter was intriguing. Her technical equipment was formidable. But there was something about each work that made it hard to like—perhaps the raw primary colors, perhaps the deliberate use of popular images and the formal overtones of popular art. Only when I met the artist, read her interview with Cindy Nemser, and saw much more of her work did I begin to understand and appreciate it.

While I have found works by certain abstract artists extremely beautiful, my long professional commitment to Renaissance and Baroque art, which is realistic and didactic as well as beautiful, lends the current revival of interest in American twentieth-century realism a special attraction for me—especially this newest form of realism with its inspired transformation of the photographic image. In the case of Flack, moreover, the historical parallels are important and acknowledged. She is not afraid of the past but rather is consciously and deliberately inspired by it.

Even a superficial acquaintance with Photo-Realism makes clear that Flack is one of the most original, ambitious, and influential artists using the camera to help her create her imagery. However, when her work is compared with that of mainstream Photo-Realists, she seems misplaced. She may belong in a technical sense, but the content of her art and its aims often seem very different from those of her movement

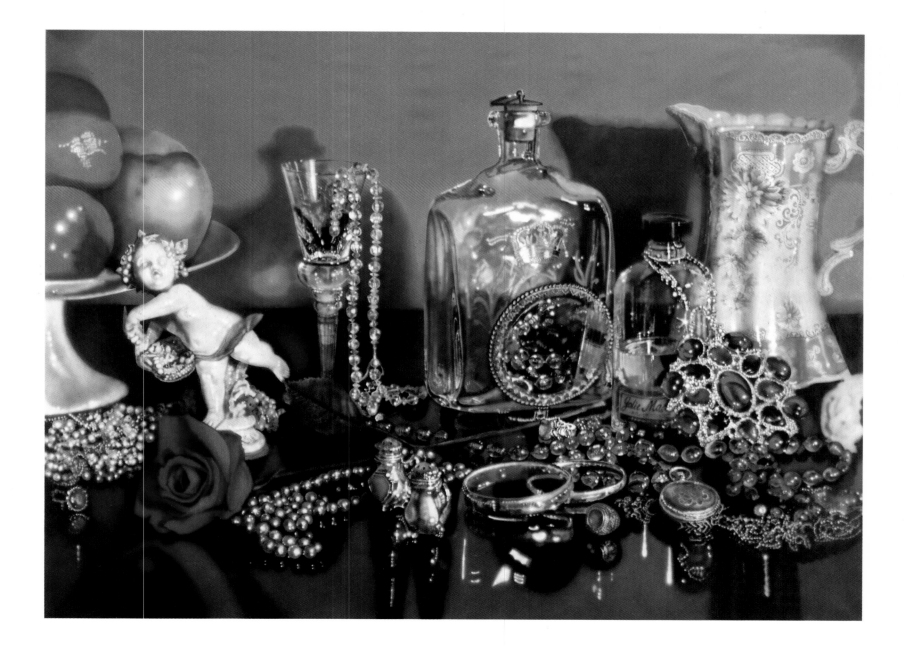

13. Details from MARILYN

peers. Photo-Realism is a style associated with uncannily skillful, photographically inspired images of ordinary urban America painted mostly in cool, neutral tones. Its landscape is bleak, treeless, inhabited by middle-aged cars rather than people, filled with aging movie houses, diners, and plate glass façades. Its typical artists paint the gleaming innards of motorcycles, curving, polished chrome, airplanes, racing cars, horses, fire engines, and perfect female nudes. When the human figure appears, it seems accidental. Facial expressions are concealed or frozen. The female nudes have often lost their heads, cropped for compositional effect as in the work of other current Realist painters. I sense in both groups a good deal of nostalgia for the ordinary America of their childhood and adolescence, together with straightforward worship of standard male idols—girls, sex, cars, machines, speed, technology.

Flack's paintings are warm in color and full of human feeling, even if figures rarely appear. Her subjects blend popular art and popular taste with other, less accessible cultural references in highly sophisticated compositions that comment both on their historical antecedents and on abstract form. It is difficult art, even if some of her meaning is easy to grasp and the immediate effect is always stunning. Her imagery does not, however, provoke that instant sense of identification with mundane experience that gives the work of her contemporaries such immediate appeal. Even if she does employ some of the stereotypical symbols of femininity—perfume bottles, lipsticks, jewelry, flowers, pretty trinkets—her message is always much more than visual fascination with these attributes of womanhood. She is not simply a woman Photo-Realist. Flack also never allows her analysis of the design and its components to dominate her theme. Her pictures must always be read for content.

Flack is deeply involved in the human content of every image she paints. One of her first experiments with a photographic source resulted in a picture of President Kennedy's motorcade at the Dallas airport shortly before his assassination. She has painted nuns on civil rights marches, Marilyn Monroe, and survivors of Buchenwald, these last two appearing in her set of three *Vanitas* paintings of 1976 to 1978. She searches always for powerful images that will speak to contemporary America about the human condition, about

love and hate, life and death. They may be drawn from the historical past, as with Michelangelo's *David* (whom she characterized to Cindy Nemser as "the archetype of masculinity—the hero . . . strong but gentle") or *La Macarena,* or from the more recent past and her own experience. Sometimes she celebrates the sensual pleasures of food, though in such a way that the paintings also become allegories of greed. Other works are her own definitions of beauty, recording the sheer visual pleasure of fruit, flowers, jewels, and the refraction of light on smooth and translucent surfaces, although here too the themes of fate, death in paradise, and the ineluctable passage of time are interwoven. Her art is enormously ambitious, taking on the most powerful and difficult moral subjects and doing so on a huge scale with colors and forms that demand attention and dominate the space in which they hang. Such work is too strong and complex for a casual encounter. Unless we are prepared to spend time with it and to be moved, even upset, we should stay away from these extraordinary canvases. They can only be taken seriously.

Many artists have tackled these subjects with more restraint, if you like with better taste. Flack will, however, eventually reach a much broader audience by stating her message in these terms. Her spectacular illusionism, the sheer glamour of her repertoire of shining beads, glasses, gilt and lustre cups, perfect roses, ripe pears, and glazed petit fours will lure an audience that would never be touched by more subtle approaches. Flack uses popular taste for serious ends. She also clearly challenges definitions of good taste and beauty.

Great art does not always make us comfortable. It cannot always be defined by the soothing sunshine of Monet and Matisse or the cool harmonies of Poussin and Vermeer. Flack is an important artist because she is disturbing, reaching for our emotional response as well as for our rational understanding. She is important too because she is never content to repeat herself. Her work is constantly evolving technically, compositionally, and thematically, and it speaks to us on many levels. She has discovered her own potent visual icons and made them meaningful to us, creating a new artistic vision that is both personal and universal.

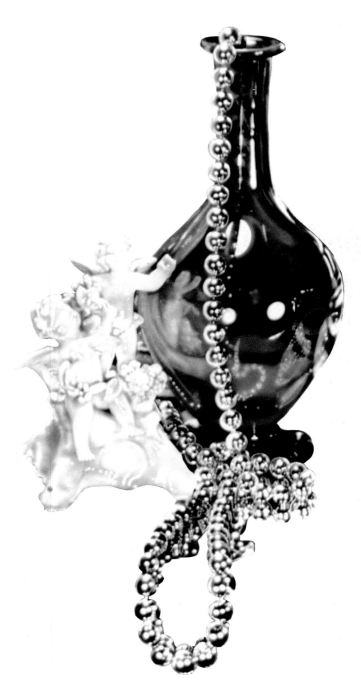

Introduction

by Lawrence Alloway

Artists' writings on their own art are a form of privileged statement, since work and commentary have an identical source. This gives a particular authority and insight to such writing, different from art criticism, which takes its origin outside the creative act. The unique value of first person writing does not, however, preclude the usefulness of art criticism. The artist naturally tends to write in terms of his or her present concerns: the art leads the writing, as it were. The critic's area, on the other hand, is that of context or development. The subject of this book is Audrey Flack's later painting, but I have tried to give a sense of the continuities of her work. I have not overlapped Flack's writings here and offer notes on her development in relation to the recent work, to supplement the esthetic and technical writing direct from the artist.

In the late 1950s Flack was aware of the desire to get away from "the broken edge" of Cézanne, but did not achieve it immediately. What she did first was to extend a gestural mode of painting to take in aspects of traditional iconography. She painted *The Dance of Death, The Three Graces, The Anatomy Lesson* (the first modern quotation of this later much paraphrased Rembrandt), and *The Four Horsemen of the Apocalypse*. In *The Dance of Death* the figures are kept close to the picture plane, with heads and feet against the top and lower edges of the painting, a form of placing that stresses surface rather than depth. Her handling is free and dashing, revealing her interest at this moment in gestural style. Grand Manner themes are not conspicuous in her subsequent work, but they should be kept in mind. It seems evident, for instance, that *The Dance of Death,* a North European moral subject, leads to Flack's later *Vanitas* paintings, another theme of Northern origin.

By acknowledging art history's precedents, Flack adds a sense of time to the space she creates in her paintings. Space can act as a metaphor of an artist's absorption in the present moment of the creative act (the responsive field of the painting) or of the unity of the end-product (the work in which everything fits). Both these ideas had great prestige among abstract artists, but Flack is clearly resistant to them as preset limits. The time of history is added to and becomes inseparable from the space of painting. Her adoption of photographic sources a few years later does not conflict with her

15. Dance of Death. 1959.
Oil on canvas, 6 × 8'.
Collection the artist

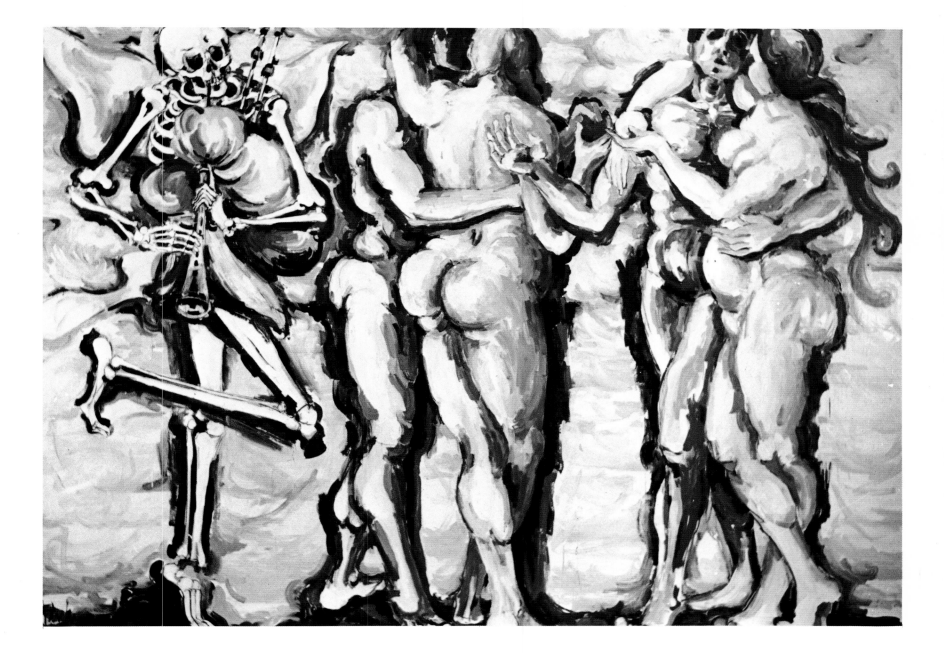

Old Master interests. Both modes present us with mediated images: we view the world either through the iconographical quotation or through the simulated photograph. In both cases we are perceiving the world through the screen of a pre-existing convention avowed by the artist.

In 1962 there is a sudden contraction of the scale of her work in a group of "product" still lifes. These are a significant step in the direction of her later still lifes, as well as a modification of the genre. As a rule, still-life artists have tended to paint generic objects rather than specific products. Flack's decision is one that acquires its full meaning only in relation to her later work, but at the time it might have been a response to Pop art, setting commercial products into an articulated three-dimensional Realist space. Two of these works are food-based—*Royal Jell-O* and *Matzo Meal,* and one is titled *Cosmetic Still Life,* implying respectively the kitchen and the bedroom. Visible words in *Cosmetic Still Life* include "Helena Rub . . . ," "Beauty Washing . . . ," "Cover Girl," "Erotique," and, though not fully legible, "by Noxema." It is a modest anticipation of *Jolie Madame,* the painting in which, ten years later, Flack fused her interest in objects and her historicism, as we shall see. The Old Master paintings and the still lifes both exist as small groups, which suggests that they may be taken as work addressed to particular problems.

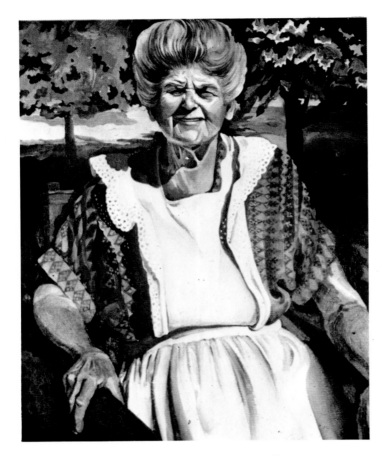

16. TANTE FEIGE. 1967. Oil on canvas, 30 × 25″.
Collection Mr. and Mrs. Herman Greenberg, North Miami, Fla.

How remarkable it is to see in art a woman of considerable years whose beauty does not depend on her youth, wealth or high breeding. We have always had "masterpieces" of dignified, elderly gentlemen, but in what painting, old or new, does the average woman, who has passed the age, defined by men, as sexually available, appear with any sense of personal power or vitality.

Sarah Whitworth, "Audrey Flank: Three Views"

17. ROYAL JELL-O. 1962. Oil on canvas, 9 × 12″. Private collection

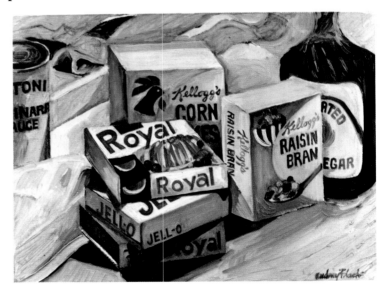

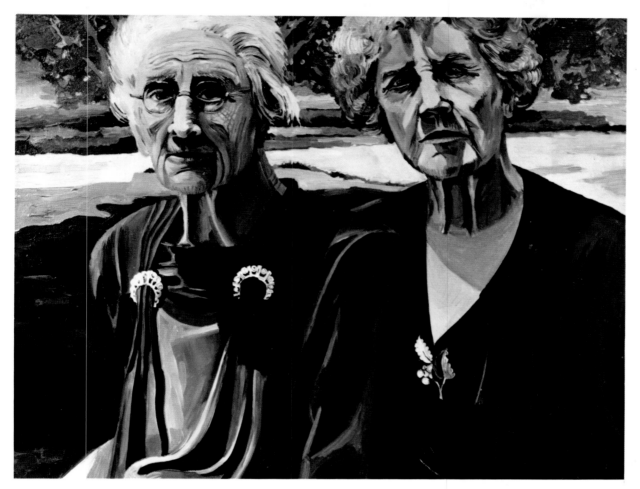

18. TRUMAN'S TEACHERS. 1964.
Oil on canvas, 20 × 30″.
Collection Beverly and
Hyman Dolinsky, New York

Larger themes emerged immediately, however, the first a series of portraits of older women, from 1963 to 1965. These paintings rest on the basis of portraiture, such as *Tante Feige*, in which a relative of the artist is presented intimately: she is seated (relaxed) but wears an apron (implying work), looking directly at the artist, whose viewpoint is of course the same as ours. Flack is working from a standard family album kind of snapshot: the sun is behind the photographer, showing the sitter's form clearly; and the light in her face makes Tante Feige squint. The photographic source is unmistakable, but this is not what we came later to understand as Photo-Realism. On the contrary, Flack's handling of pigment is blunt and painterly: the medium defends the image from

disappearing into a photographic realm, as it were. According to Flack it was during the years 1963–64, as she became increasingly interested in the pictorial uses of photography, that she became involved in disputes with other Realists concerning the validity of the quoted photograph.

The sense of portraiture was extended in two works of 1964 which depict real people, but not ones known to the artist: *Harry Truman's Teachers* and *Two Women Grieving Over Kennedy Outside a Dallas Hospital* are both taken from magazine photographs. Thus Flack's attention is shifting from personal contact to representative public figures, though both phases share a sense of women in terms of age, work, and stress. She is taking imagery from the mass media to ob-

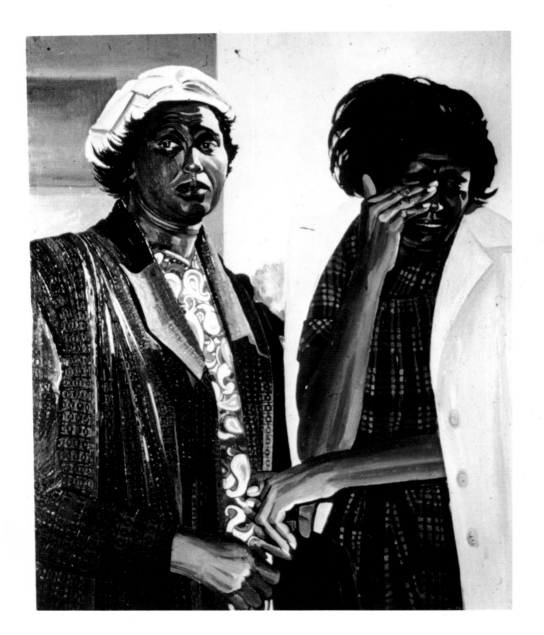

Unlike the usual portrayal of a purely sentimental attachment between women, this is a friendship of understanding and reinforcement that is a vital necessity to both individuals.

Sarah Whitworth, "Audrey Flack: Three Views"

Behind the old woman, to the left, there is a young girl in braids who looks out at us skeptically from the corner of her eye with a knowing glance that alludes to an opposing idea of sophistication in youth. But both women, oddly, share a kind of belonging to their situation and environment that is so often absent in the perplexed faces of the masses going to and fro in our urban cities. . . .
 Stylistically, Flack's insight is due, in part, to the fact that she works directly from unposed photographs which have a way of presenting life as it is and not as the artist might have it be. But her choice of photographs is the result of her particular interest in human form which concerns itself with the emotional complexity of a personality . . .

Sarah Whitworth, "Audrey Flack: Three Views"

19. TWO WOMEN GRIEVING OVER KENNEDY OUTSIDE A DALLAS HOSPITAL. 1964. Oil on canvas, 36 × 28″. Collection Edward Lamb, Toledo, Ohio

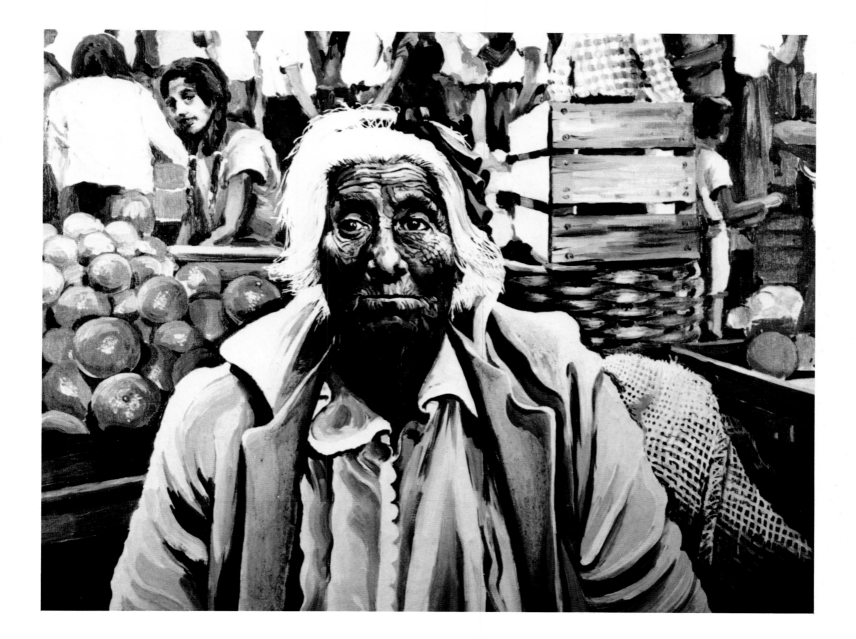

20. OLD MEXICAN ORANGE SELLER. 1966.
Oil on canvas, 20 × 26″.
Collection Jerome Spiller, New York

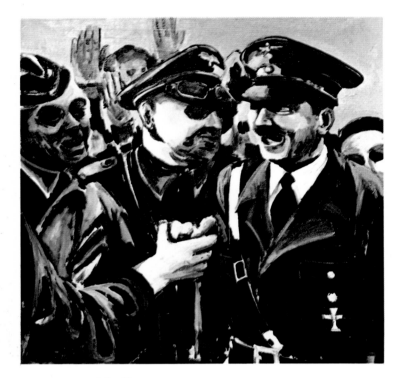

21. HITLER. 1963–64.
Oil on canvas, 28 × 28".
Collection the artist

22. KENNEDY MOTORCADE, NOVEMBER 22, 1963. 1964.
Oil on canvas, 38 × 42".
Private collection

tain access to moments of emotional, public intensity, stressing their shareability. This theme was continued in her studies of Mexican women, with their sun-dried faces and indeterminate ages—much younger than their North American contemporaries. They are based on Flack's own photographs of peasants in the market at Oaxaca. Though broadly painted, the sitters' direct address to the viewer, as well as the split between foreground and background plane, are emphatically photographic. The camera is used not to set up a criterion of visual appearances but as the means of access to a social reality of which she could not otherwise take hold.

Because photographs catch brief moments in the flow of time, we tend to think of painters using photographs as involved in the configuration of ephemeral events. However, this is not the only function of the camera and certainly not Flack's main interest in it. In the realm of public life, for instance, photographs provide the iconography of leadership and crisis. The painter of contemporary history who draws on photographs is inevitably linked to the world of types as well as of observation. Flack painted a group of public personalities. In the *Rockefeller* painting she depicts the politician at a moment of glad-handing arrival: it is a study of characteristic public gesture. In *Hitler* she tackled another problem, coaxing a news photo of the 1940s into a psychological history picture: how do you paint the good humor of an evil man? (The survivors of Buchenwald appear in a later picture of Flack's.) In her painting of the Teheran Conference—Churchill, Roosevelt, and Stalin together near the end of World War II—the group radiates benevolence, but we know their relationship was based on competition and distrust. Flack's image of John F. Kennedy, *Kennedy Motorcade, November 22, 1963,* makes a similar sharp use of our knowledge of recent history: it shows, and who does not know it, the start of the motorcade in Dallas in which he was assassinated. The arrogant leader-image thus becomes elegiac. Flack's public-event paintings depend on the time-lapse of recent history which enables us to judge the photographic image in a temporal frame.

The Kennedy painting is the first to be derived from a color photo. Previously Flack's sources had been black-and-white, with the color, usually pretty sober, invented. As part of her

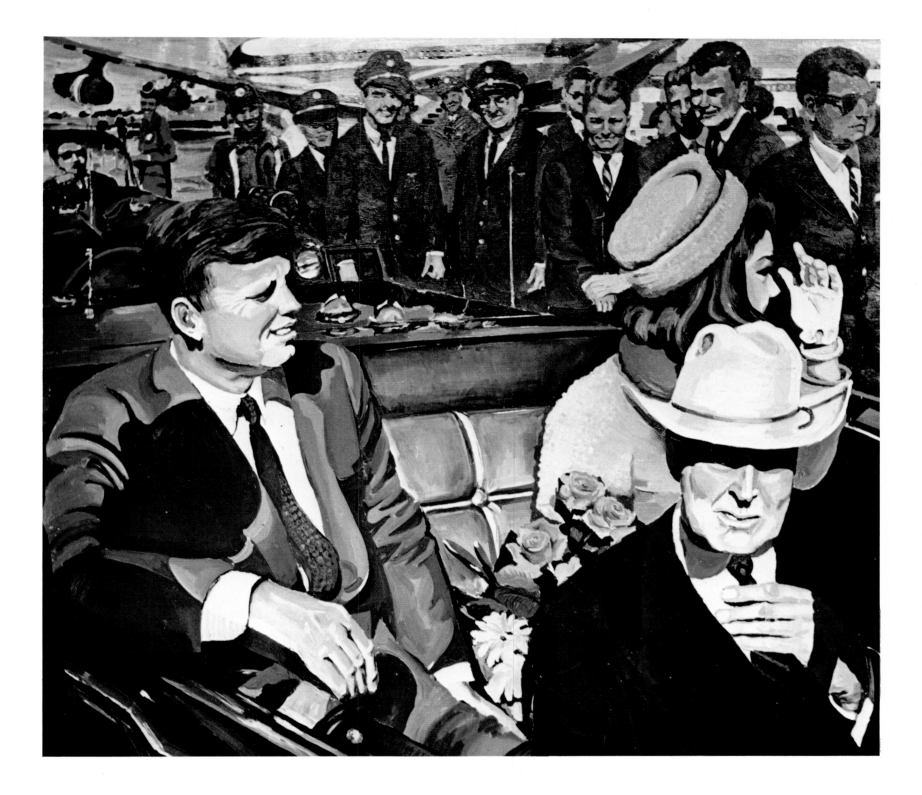

23. CARROLL BAKER. 1964.
Oil on canvas, 20 × 16″.
Private collection

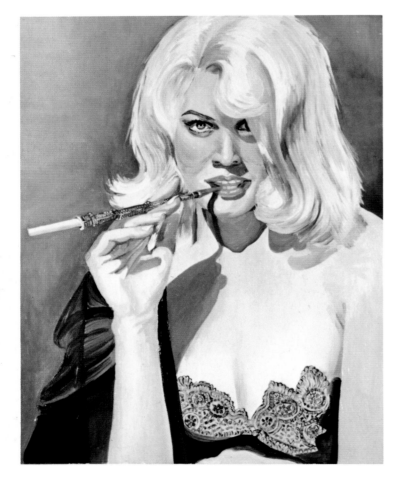

mounting interest in color she made several ideal pictures of movie stars in which the figures are given in terms of a single flow of color that undulates throughout the canvas. These are in startling contrast to the grainy, tonal basis of the public-events pictures, which possess a kind of evidential grittiness. The movie stars are creamily painted, as if the pigment no less than the bodies of Marilyn Monroe or Carroll Baker is to convey the golden life of the senses. The stereotypes of glamour—blonde hair, warm flesh, inviting smiles—are extended into the stroked paint. These public women are antithetical to Flack's iconography of older women, but they are in ironic correspondence to the male politicians Flack was painting.

There are several paintings that combine the specificity of Flack's photo-derived work, a political iconography, and an increasingly complex formal structure. In one of them, *Young Mexican Farmer in Oaxaca Market,* she keeps the snapshot format, a foreground figure aware of the camera, with a background of random events, but bases a monumental figure composition on the format. A foreground pyramidal group is meshed with the active poses of the distant figures. Another is *War Protest March,* which can be viewed as a more coloristic version of Flack's earlier *Sisters of the Immaculate Conception Marching For Freedom,* an incident of the Civil Rights Movement in which nuns tried to protect black protesters by walking with them. It is a frontal work, implying the unstoppable advance of the crowd, but the later march is spatially more elaborate. The marchers move obliquely across the field of vision, seen at various points from close-up to middle distance and defined by a complex internal play of planes. Color is more diverse and Flack preserves a full tonal range of light and shadow from white to black, which leads to the decisive *Farb Family Portrait,* 1969–70.

The painting that announced Flack's interest in the Spanish Baroque is *Macarena Esperanza,* but that theme was present earlier. Consider *Farb Family Portrait,* the first painting Flack did from a slide: the figures have the frontal pose and lens-awareness of lay portraiture, but they emerge in gleaming color from a dark background, like an early Baroque figure composition. At another level we should not forget the Mexican peasants: the *Macarena,* though located in Seville, Spain, is the kind of devotional image which would

24. YOUNG MEXICAN FARMER IN OAXACA MARKET. 1967–68.
Oil on canvas, 40 × 62".
Collection the artist

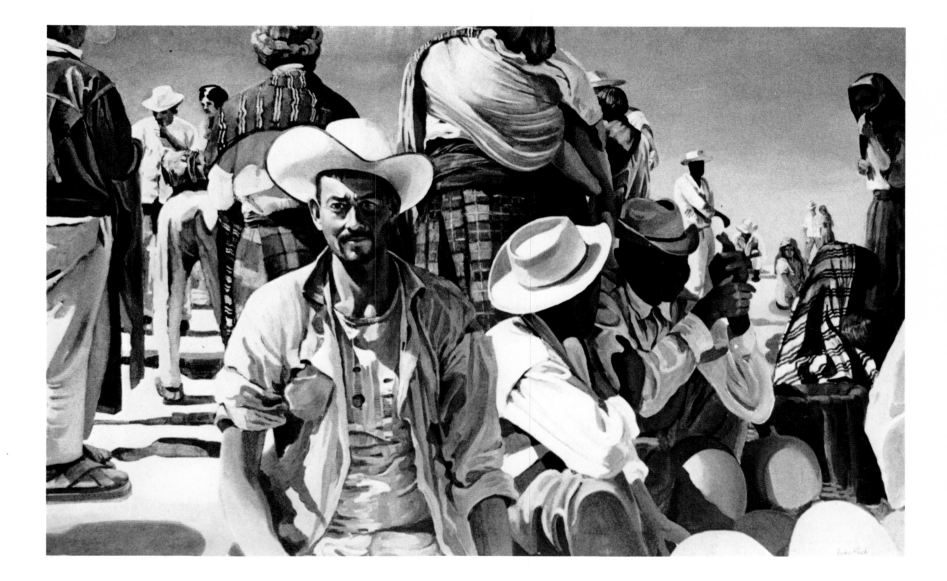

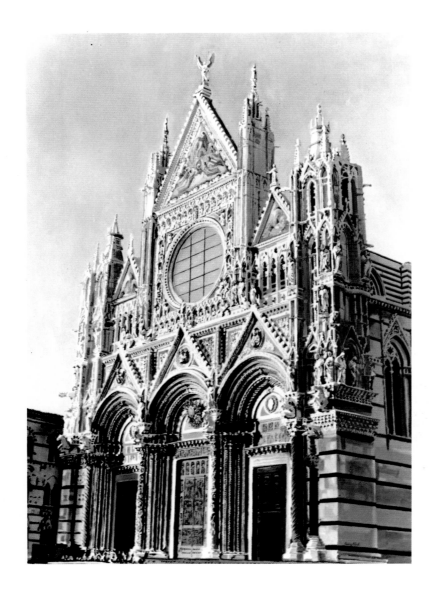

have been shown in Baroque Mexican churches. Thus, though the dusty peasants are not present in Flack's later works, the high finish and luster depict illusionistic church sculpture that would be congenial to them. Flack has commented that she was anxious to assert the *Macarena*'s status as a masterpiece. "I wanted to do this not by removing the ornamentation, but rather by including every bit of drapery, lace, jewels, chains, and gold."[1] Thus the social implications of the paintings of peasants and the illusionism by which Flack rendered the cult image were fused in the four versions she made of Hispanic church sculpture.

After the *Farb Family Portrait,* Flack began in 1971 the works to which this book is devoted. They were made possible by the convergence of her interest in art and photography, her historicism, and her sympathy for the Baroque. The first of the new works is *Siena Cathedral,* showing the west end, steeply angled as in a photograph, alive with niches, tympani, crockets, and finials, rendered with glowing fidelity. The illusion is not that the architecture itself is present, of course, but that the painting matches a deep-focus photograph. The next work was of the Cathedral of Amiens, and it was taken from a slide Flack bought in Italy, one of a series devoted to the Treasures of Art, and is captioned "la facciate e il fianco sud." Thus the presence of the object is not a necessity for such a painting: the information transmitted by a photograph is sufficient. This does not mean, of course, that the subject means nothing to Flack. On the contrary, in the European monuments she has created a garland, brilliant in color, which draws on both art history and tourism for its imagery, in opposition to the urban naturalism of most Photo-Realism. Whereas other Photo-Realists sought the familiarity of the everyday, Flack wanted the familiarity of the enduring. The Leaning Tower of Pisa or her painting of the copy of Michelangelo's *David* outdoors in Florence are clichés but rich ones, clichés with a future as well as a present usage. Their adoption and use in the general culture are a part of their value to Flack.

Pop art, especially the silk-screened photographs of Andy

25. SIENA CATHEDRAL. 1971.
Oil on canvas, 66 × 46″.
Collection Louis and Susan Meisel, New York

[1] "Luisa Ignacia Roldán," in *Women's Studies*, vol. 6, pp. 27–28. New York: Queens College Press, 1978.

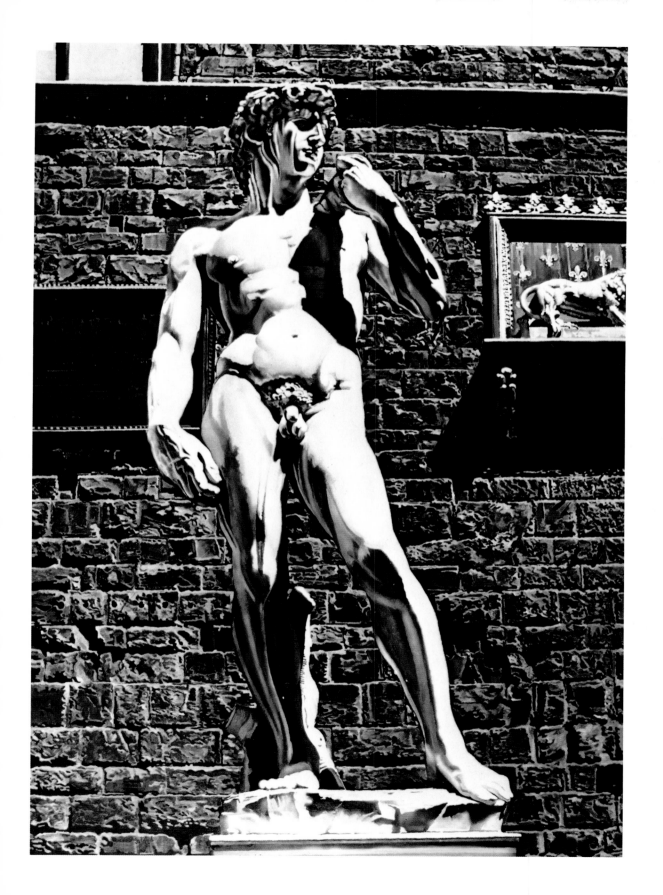

26. MICHELANGELO'S DAVID. 1971.
Oil on canvas, 66 × 46".
Private collection

Warhol and Robert Rauschenberg, signaled a crisis among figurative artists. Some artists were certainly on their independent ways to decisions on what to do about photography: it was a widely shared problem. Photo-Realism, for instance, as it developed in the middle and later 1960s, continues the Pop art emphasis on channel switching, roving between photographic reproduction and unique painting. We saw that Flack made extensive use of photographs in the preparation of paintings before entering the equivocal realm of paintings that simulate photographic image-properties. Her composition and iconography use the artistic resources of channel-switching brilliantly, precipitating us into a zone in which the sense of fact and illusion are activated equally.

The earlier paintings of 1971, the two cathedrals, *Tower of Pisa, Ammanati's Neptune Fountain,* and *Sunset Over Florence* consolidate the closed surface, fine detail, tonal continuity, and rich color of *Farb Family Portrait.* Their photographic sources are displayed in Flack's meticulous matching. The later paintings of this marvelous year, such as *Michelangelo's David* or *The Piazza of Miracles,* reveal Flack's first use of the airbrush. The airbrush made possible the deposit of color in seamless areas, without line or direction. The use she made of it is essential to her later work.

The airbrush was devised as a photo-retouching tool, a spray that mixes diluted paint with air to project a paint deposit that can match the grain of photographs. Chrome trim can be enhanced or pubic hair effaced. In addition to the service function of blending well, a graphic style developed based on the medium's ability to produce smooth gradients of tone and color. In the 1930s there were posters by A. E. Cassandre and *Fortune Magazine* covers; pin-ups in *Esquire* and the first Vargas calendar in 1940, sometimes with Ziegfeld girls as models. Walt Disney's *Pinocchio,* 1939, was the first animated cartoon to draw on the airbrush's peculiarly supple blandness of tone.[2] Thus a range of glowing light and fading shadow became associated in airbrush usage with the objects of technology and show business. Flack has completely changed these terms of reference, but kept something of the original sense of wondrous depiction, the world made strangely bright, that is the airbrush's gift to illusionism. Flack has kept this sense of wonder even as she assimilated it to the density of easel painting.

Flack's European monuments can be read as a form of still life. Of course there are plenty of spatial cues, but architecture covered with enumerative detail is not always dimensionally clear. Her choice of subjects reminds one of her appreciative description of Carlo Crivelli, an artist whom she greatly admires: ". . . the agitated line, the multiplicity of detail, the crowding of areas, jam-packed with objects, decorated, bejeweled."[3] As old-established sites, each monument occupies a clearly defined area, like a tabletop in a sense. (In addition, slides, from which all the monuments are painted, are notorious for their dissolution of scale.) From object-laden forms of architecture, then, it was logical for Flack to move to still-life objects, often painted over-lifesize and rich in allusion. Her sense of time, persistently stated in her earlier work, finds its proper vessels in still life. The objects in *Jolie Madame* and the paintings that succeed it are stylistically diverse and, taken together, rich in residual historical connotations.

The notion of still life to which I am comparing Flack's European monuments is not like that of early twentieth-century practice. The tendency of artists and their interpreters was to stress objects as geometric forms or accents of color, which provided the artist with an inventory of straight lines and curves, of concavities and convexities, but were of little interest in themselves. Obviously the monuments that Flack painted were culturally weighted; it seems as if the humanist values of her figure paintings were transferred to objects. In her paintings of Michelangelo's *David* or Luisa Roldán's *Madonna,* Flack combines the resources of figure painting and still life. In *Jolie Madame* she develops a full range of "speaking objects." The ornaments and jewels have been shaped by decorative tradition so that they are a microcosm of our culture. Ornamental forms have histories, like lions' paws on furniture legs (which lead via Napoleon back to Egypt) or rosebuds on the silver (which evoke Renaissance

[2] Information from Elyce Wakerman, *Air Powered: The Art of the Airbrush.* New York: Random House, 1979.

[3] "Carlo Crivelli." Unpublished manuscript, 1979.

pastorals and medieval herbals). *Jolie Madame* is the start of an extraordinary series of works in which the time-binding potential of objects is expanded and the formal possibilities of still life elaborated to monumental scale.

Jolie Madame established at one stroke Flack's characteristic mode: a complex hierarchy of objects that occupy a spatial maze. Each object contributes to the tangle of the whole, but without loss of its specific contour and color. Thus the sense of profusion that belongs to most of her still lifes. Having achieved this synthetic mode, which became the basis of her major work, she set it aside temporarily in two groups of still-life paintings organized on a different basis. In 1972–73 there were several paintings, such as *Rich Art* and *Crayola,* in which Flack created all-over compositions out of heaps of similar objects. These were followed in 1974 by food pieces in which the principle of internal intricacy was suspended in favor of close-ups of sundaes, cakes, and tarts. However, the complex still lifes continued to thrive, with *Royal Flush* and *Solitaire* in 1973 and the *Gray Border* series, mainly of 1975–76, which includes *Buddha, Leonardo's Lady,* and *Gambler's Cabinet.* The definition of objects becomes ever more precise and the web of connections between them tighter. The cross-indexing, as it were, of individually dense objects, combined with lustrous, closed-surface color, achieves an unprecedented fullness of object definition.

Flack's three *Vanitas* paintings are a logical move in her development, rooted in the earlier work, but the immediate inspiration for them was Maria van Oosterwyck's *Vanitas,* painted in 1668. Flack saw her painting in 1976 and responded both to its Baroque ardor and moral imperative. Flack's paintings, unusually large for still life, are eight feet square, a climax of her sense of proliferating composition.

They are discussed by the artist, and I want simply to point out here the way in which illusionism permits her to depart from vanishing point perspective and reliance on a continuous ground plane. Spatial discontinuities and elisions occur among the plausibly solid objects, creating a labyrinthine spatiality. In *Marilyn,* for example, a lipstick in orbit overlaps the monochrome photograph of the star and recurs in the mirror reflection as if it were being applied to Marilyn's lips. However, the web of formal correspondences holds the intensified objects together with marvelous ease.

There is an important point to be made concerning Flack's use of scale. The dilation of objects in immense close-up does not reveal the flaws and fissures that exist below the level of ordinary vision. Here is a nondestructive enlargement that celebrates the integrity of objects. In the *Vanitas* paintings objects may be emblematic of death, but their unified surface, their wholeness, preserves our normal experience in the sight or handling of objects. Thus Flack's magnification does not lose the specific identity of objects, her sense of their completeness.

The spatial intricacy and color intensity of Flack's work since 1971 is in opposition to the reductive tendencies of American art as either a voluntary poverty of materials or a frugal display of elements. Criticism of her work has sometimes proceeded on the assumption that reduction is the only valid way to work and that her art must be in some way instinctual or indulgent. It is important, however, to stress that Flack's capacity to be bounteous is acquired. Her later richness is not the result of virtuosity but the product of intention. Flack's skills are bound to expressive themes embedded in her work as a whole. The initial forms of her ideas and themes lead step by step to the high eloquence of her later art.

Some Notes on Art and Life

Nothing real can be threatened. Nothing unreal exists.

Anonymous, A Course in Miracles.

Art is a powerful force in the world. It is the visual representation of what we think . . . what we feel . . . how we think . . . how we feel. Art makes life more livable, more beautiful, more comprehensible. It helps us deal with the basic fact of our physical mortality. Someday people will live for hundreds of years, and will look back on our society with wonder at the basic tragedy of an all too brief existence. At that time the nature of art will change. From ancient times until now, and up until that future time, art has dealt with and will continue to deal with all that is perishable in the world, and attempt to reach a higher reality—to fill the soul, to excite the mind, to go beyond. Its message cuts through time and space and lasts for centuries. Art is a protest against death.

I could never imagine a life without art, and have often wondered how people could find meaning in life without it.

My own creating of art, as well as studying the work of other artists, has sustained me through times of poverty and personal tragedy. Many evenings I held my strangely beautiful, mute, autistic child in one arm while I painted with the other.

The Metropolitan Museum of Art, the Museum of Modern Art, and the Hispanic Museum were second homes for me. I wandered their halls looking for answers, solace, and understanding, and there was always someone who spoke to me: Giotto; Mantegna; Antonello da Messina with his beautiful soulful self-portrait; Carlo Crivelli, long a favorite of mine—I studied the expressions in his canvases—grimacing, frowning, always intense; Rembrandt's self-portraits; Tintoretto; Rubens. Later, Mary Cassatt, Kaethe Kollwitz, Cézanne, Pollock, Kline, Luisa Roldán, Martínez Montañés, Rachel Ruysch, Peter Claesz, Willem Claesz Heda, Jan Davidsz de Heem, the pre-Raphaelites, Bouguereau—all message givers.

I have been called a Realist. If the definition of a Realist is one who faithfully mirrors reality, I am not a Realist. I have also been called a Photo-Realist. If that definition is of one who simply copies a photograph, I am not a Photo-Realist. I prefer the term Super Realist. I will often exaggerate reality, bringing it into sharp focus at some points and blurring it at others. An apple is never red enough, nor a sky blue enough. There is a green lime in *Wheel of Fortune* that became more acidic and brightly colored by the day.

At first I painted it a naturalistic lime color, but when completed, it was super-intensely green. It reads to the viewer as a highly realistic fruit. It is, however, more real than real. It is not realistic at all. I had had the experience of seeing full-color reproductions in art books and then seeing the original paintings, which paled in comparison to the reproductions. I did not want that to happen to my work. I also realized how accustomed our eyes have become to intense color. Kodacolor blue sky is hardly natural. TV color is not realistic.

I intend my work to exist on many levels. One is the simple fact of recognizable imagery. It is important for me that the objects I depict are easily recognized by the viewer. I consider that a gift from the artist. I always feel joy when I can recognize St. Peter with his keys, St. John wrapped in animal skins, St. Sebastian pierced by arrows, and so on. Recognition is an entree into the painting . . . an invitation . . . a relief . . . a comfort and an enticement to continue on toward further depths. The image is only the tip of the iceberg. There are great worlds beneath. The Realist gives power to the viewer—who can judge whether the work is well executed or not. If a hand, a face, or a drape is painted incorrectly, the viewer sees it and can criticize it, whereas he or she must accept the word of the abstract artist.

I once overheard a person at an exhibition who stopped in front of a Willem Claesz Heda still life—an artist I dearly love—and loudly exclaimed: "This is awful, just a photographic imitation." He had learned the modernist language so

27. MELISSA AND ME. 1959.
Oil on canvas, 19 × 26″.
Collection the artist

29

28. HANNAH MARIE (MICKEY MOUSE HAT). 1965.
 Oil on canvas, 10 × 8″.
 Collection Hannah Flack Marcus, New York

29. PORTRAIT OF MELISSA. 1964.
 Oil on canvas, 15 × 10″.
 Collection the artist

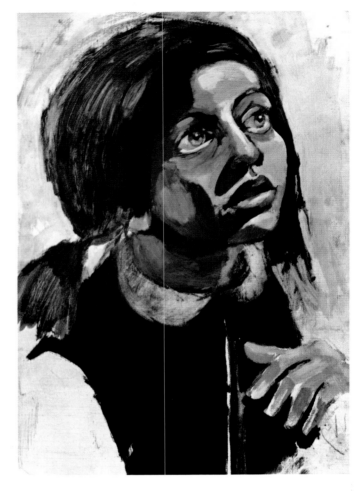

well that the sight of a photographically real painting offended him. Had he really understood modernism he would have been able to see the underlying abstract elements in Heda's work. He was completely blind to the exquisite and ethereal world of Heda.

My work is highly symbolic and iconographic. An apple takes on meaning beyond itself. The apple is red or green or yellow or various mixtures depending on what I am trying to say. It can be rotting or fresh . . . sliced or whole . . . pure or scarred . . . full or shriveled. It can be the apple Eve presented to Adam; Marilyn Monroe's apple (I saw her as a peach color, and the apple I used in the *Marilyn* (*Vanitas*)

was a soft yellow mixed with a pinkish orange-red); Snow White's apple; Red Riding Hood's apple; the Big Apple.

I believe in universal symbols, Jungian archetypes. Everyone will understand the difference between a black rose and a white one . . . a rose that is open and full and a tightly closed young bud. All of the objects are carefully selected in terms of the feelings I hope to evoke in the viewer.

My work is also highly abstract and formalist. An apple becomes a color, a shape, a weight, a density, an abstract circle to be positioned in space at a very specific point—to come forward and break the picture plane as in *Spaced Out Apple,* or to recede. The objects become means to an end. The

cigars in *Royal Flush* are diagonals violently opposing each other. The composition of *Royal Flush* has always reminded me of Jackson Pollock's *Blue Poles*. My roots are abstract. I knew the Abstract Expressionist painters and was profoundly involved with their work. I was particularly influenced by Pollock.

It is the aim of my work to bring all of these elements together . . . the object itself . . . the symbolic iconography . . . the abstract formalism.

Every artist has an audience in mind for his or her work. James Joyce created *Finnegans Wake* for the few who would take the time and effort to sort through volumes of material in order to comprehend a line. I hope to reach many people, all at their own level. The Shakespearean plays, which are still being interpreted by scholars, were instantly understood by the people of his time. To quote Cliff Joseph of The Black Emergency Cultural Coalition, "The power of Art belongs to the people."

Art reflects, documents, comments upon, or commemorates the time in which we live. People are hard-pressed now. We live in a society which is decaying and polluting itself. We face universal destruction, emotionally and physically. It seems to me that at this time of betrayal of hopes, a victory for art matters desperately.

The Haunting Image of the Macarena Esperanza

Somewhere in my mind I think I have always seen the particular image of Luisa Roldán's *Macarena Esperanza,* the patron saint of Seville. I produced a piece of sculpture years ago which bore an uncanny resemblance to the *Macarena,* long before I ever saw or heard of it. A Jungian friend of mine said I was the reincarnation of Luisa Roldán. At first I thought it absurd; now I consider it. In the early 1960s, a friend visiting Spain sent me a postcard of the *Macarena Esperanza* saying that the work reminded her of me. The image haunted me.

In 1970 I traveled to Spain heavily laden with camera, tripod, and assorted lenses. I went from church to church taking photographs of angels, statues in corners, and Churrigueresque *retablos.* I was very nearly arrested, for in religious Spain it is a sacrilege to set up a camera and tripod in front of these icons. I arrived in Seville and sought out the *Macarena.* It was ensconced in a church in a poor section called Triana. The facade of the church was unimpressive, but when I entered, I had an overwhelming experience. The *Macarena* was standing there in all her glory, magnificent and serene. This masterpiece sent out vibrations which produced in me an electric sensation like one I had experienced when I stood in front of a Botticelli tondo at the Morgan Library in New York.

I stood awe-struck in front of the *Macarena.* I had seen many statues before, many saints, many madonnas, but never had I experienced anything like this. I searched the church frantically for someone who knew the origin of the statue. I finally found an old Spanish tour guide, and in my faltering Spanish I asked him if he knew the artist's name. "Si, si," he replied, "La Roldana." Recognizing the feminine article, I realized that this work that had moved me so had been created by a woman. I said, "A woman?" And he replied, "Of course a woman. No man could ever create a face that beautiful!" There was an assumption of a feminine aesthetic. The work was superior and marvelous because it was an interpretation of a woman, Mary, by a woman, Luisa.

But there was another connection between Luisa Roldán and myself. I had grown up near the Spanish Museum in New York City. It was one of the most beautiful and spiritual places in the world to me. I did not know until very recently

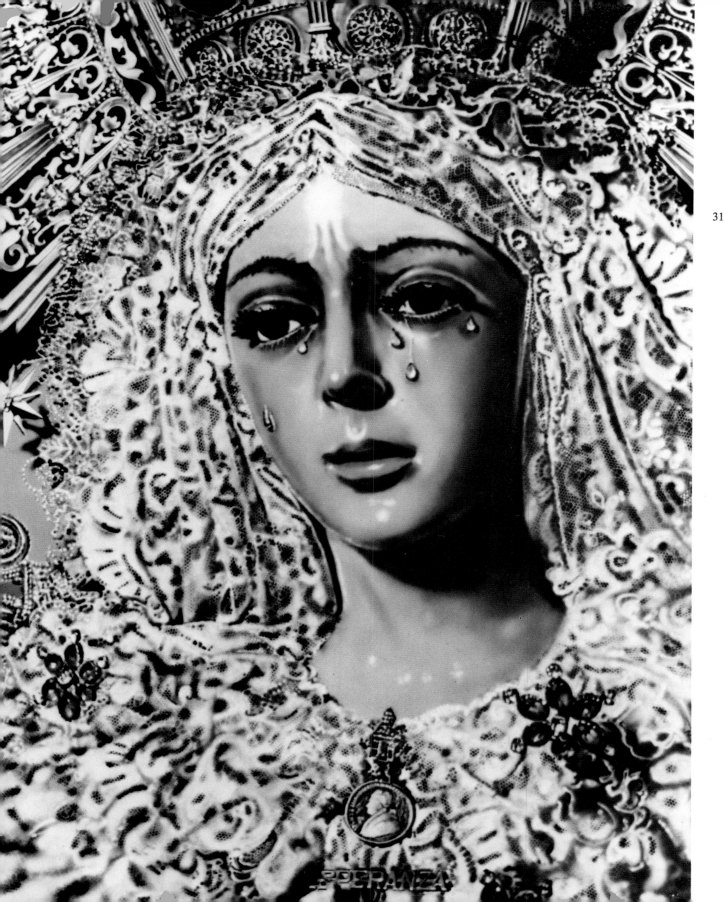

31. MACARENA ESPERANZA. 1971.
Oil on canvas, 66 × 46″.
Collection Paul and Camille Hoffman,
Charlottesville, Va.

that several of the statues on exhibition which I often gazed upon were by Roldán. I was drawn to the passion, vitality, and humanity of the works in the Spanish Museum and, without knowing it, from the time I was very young I had been absorbing the work of Luisa Roldán. So somewhere in my development as an artist, the solace and inspiration I received from this museum turned up in my later life and in my work.

I love the art and especially the sculpture of the Spanish Baroque. Unfortunately, the great Spanish Baroque sculptors have not been afforded sufficient historical attention. Luisa Roldán is famous in Spain but virtually unknown here. And though she died in the seventeenth century, I now feel very close to her artistic successes and failures, her financial worries, and her concern for her family.

Luisa Ignacia Roldán is the first woman sculptor in Spain whose work has been recognized and documented. Her name has become so legendary that any work of the late seventeenth century showing delicacy is attributed to her. She was born in 1656 and died in 1704. Her father, Pedro Roldán, was a sculptor who put all his children to work. (Many women artists we have "uncovered" have been the daughters of artists.) There were three daughters and two sons and, regardless of sex, they all worked at the family trade, as did many of Bach's twenty children. Luisa started to produce excellent pieces and her work soon surpassed all the other work in the shop, including her father's.

Luisa married at the age of fifteen, as was then customary. What is unusual is that she retained her maiden name and signed her work Luisa Roldán. She married Luis de los Arcos, a sculptor, who is known only through joint contracts with Luisa. He, too, must have worked for her father. After their marriage Luisa and her husband moved to Madrid, where she hoped to be employed by the king and eventually to be appointed sculptor to the court. She achieved her first success in 1692 with her appointment as Sculptor of the Chamber. The government was terribly corrupt, and there was very little money, and even that was squandered. Despite the title, there was no salary allotted to her. She was forced to petition constantly for gratuities for herself and her family, writing first to Queen Mariana of Neuberg and then to the

Constable of Castille: "I am poor and without a house for myself or my children. With the use of this room (a vacant room in the Casa del Tesoro) I would have some relief, because my need is very great."

She was granted an annual salary, but collecting it was not so simple. She again petitioned the king: "For the love of God, kindly allow the constable to pay me, indicating from which funds." New problems arose. The council imposed an advance salary tax and she could not afford to collect her own salary. Two years later she was still so hard-pressed that she wrote a letter to the queen reminding her: "For more than six years I have had the good fortune to be at your royal feet, executing different figures for the pleasure and devout purposes of your majesty and, considering that I am poor and in great need, I beseech Your Majesty to be kind enough to give me clothing or a gratuity, or whatever Your Majesty pleases." This plea touched the queen, who on January 25, 1697, ordered 25 doblones paid to her. But a few months later Luisa made an even more desperate appeal: "Because I am poor and have two children I am suffering great want and on many days I lack enough to buy what is necessary for daily sustenance."

During this time of great need, Charles II died, and she appealed to his successor, Philip V: "When I was about to gain reward for hard work and study, God took the King (Charles II) to himself. . . . Thus I have had to pay so much for the expense of these works, and I am so greatly in need, that I do not have the necessary means to support myself and my children. For this reason I am forced to beseech Your Majesty to be kind enough to order that I be given wherewith to buy food for myself and my children and a house in which to live."

Soon after, she was appointed Sculptor of the Royal House of Philip V. The appointment came too late, however. Hardship had shortened her life, and she died that year at the age of 48. The handwriting in her last petition to the king is cramped and weak, for her hand was shaking as she wrote. But in the midst of all her troubles she was still producing sculpture, and was asking for money so that she could continue to create.

Like her father, Luisa Roldán and her sculptor husband

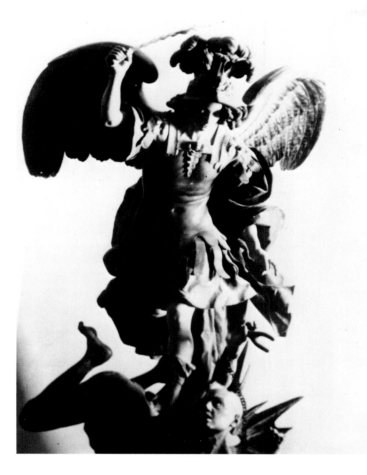

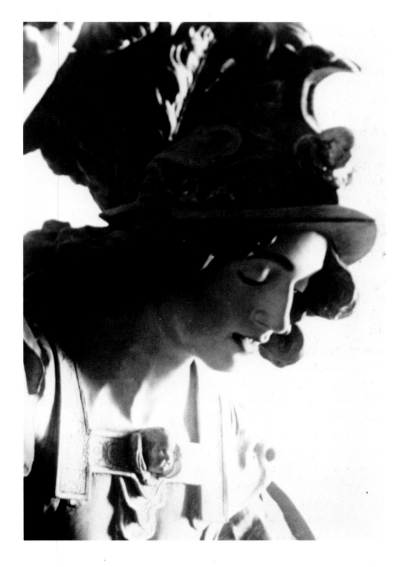

32. Luisa Roldán.
St. Michael. 1695–1700.
Polychromed wood, life size.
Real Monasterio de San Lorenzo
de El Escorial, Escorial, Spain

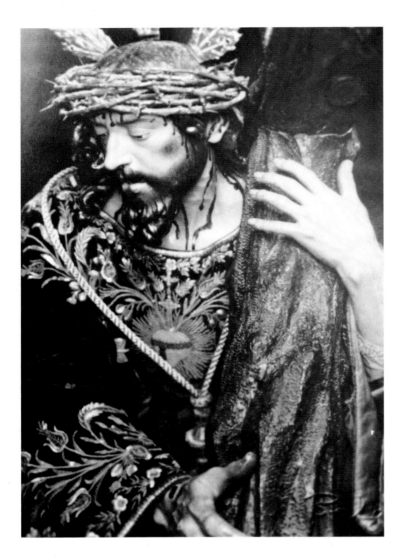

had a family workshop, and she trained her son to be a polychromer. There is evidence to suggest that after her death the family tried to maintain the studio by issuing copies of her sculpture.

The work that established her as a great artist in Madrid is *St. Michael,* which was commissioned by Charles II for the Escorial. It is an over-lifesize sculpture carved in wood and polychromed. A typically Baroque statue, it has brisk action and swirling robes. It shows St. Michael, with a flaming sword held high, stepping on a twisted, agonized Lucifer. Lucifer's leg is bent back so that the sole of one foot supports the sole of Michael's right foot. The colors are vivid. The cloak is bright red. Blue, yellow, pink, and green plumes sprout from Michael's brown helmet, which is decorated with gold. The flesh is a soft ivory tone.

Jesús Nazareno, also commissioned by Charles II, is another lifesize polychromed wood sculpture. The king died before it was completed, and it remained in Luisa's house until after her death. Her husband placed it on a desk covered by a curtain. A writer and critic of the day, Palomino, went into ecstasy upon seeing the statue. He described his emotions when the curtain was drawn:

So great was the awe that it inspired when I saw it, that it was irreverent not to fall on my knees to look at it, because it really seemed to me as if it were the subject itself. And after having spent some time examining it and admiring it, I went to sit down and look at it again. I said to Don Luis, Luisa's husband, that if he did not cover Christ, His Majesty, again, I would not sit down. Such was the reverence and respect it inspired. I assure you that the words fail me to describe it, for not only the expression of the head which I have mentioned, but the hands and feet with some drops of blood trickling down them were so divinely executed that everything seemed like the actual person.

This statue was eventually given to a Franciscan convent at Sisante in the province of Cuenca, together with a statue of the *Mater Dolorosa,* also by La Roldana.

Luisa Roldán became most famous for her small terracotta figure groups. I believe she originated a whole new form of sculpture, separate groups of sculpted figures to be seen

34. Luisa Roldán.
 Jesús Nazareno. 1695–1700.
 Polychromed wood, life size.
 Franciscan Convent, Sisante,
 Province of Cuenca, Spain

for themselves alone. It was the vogue in Seville to set up Christmas crèches—tableaus of individual terra-cotta figures of shepherds, animals, gypsies, etc. B. G. Proske, curator of the Hispanic Museum, writes: "La Roldana's nativity scenes were not true Christmas cribs in that they were complete works, not assemblages of separate figures. They were permanently on view rather than brought out just for the Christmas season, but they responded to the same taste for intimate genre scenes that inspired mangers. Probably from this source came the idea of adding interest to her groups with amusing bits of still life, flowers, and animals. They anticipate by half a century the creation of small groups in porcelain to which they seem to have such a close affinity."

The Death of St. Mary Magdalene is in the collection of the Hispanic Society. Mary Magdalene is dying, and although she is old, she is still very beautiful. She lies on a bed of rocks, holding onto a cherub. There are two predominant angels: one supports her head, the other holds a

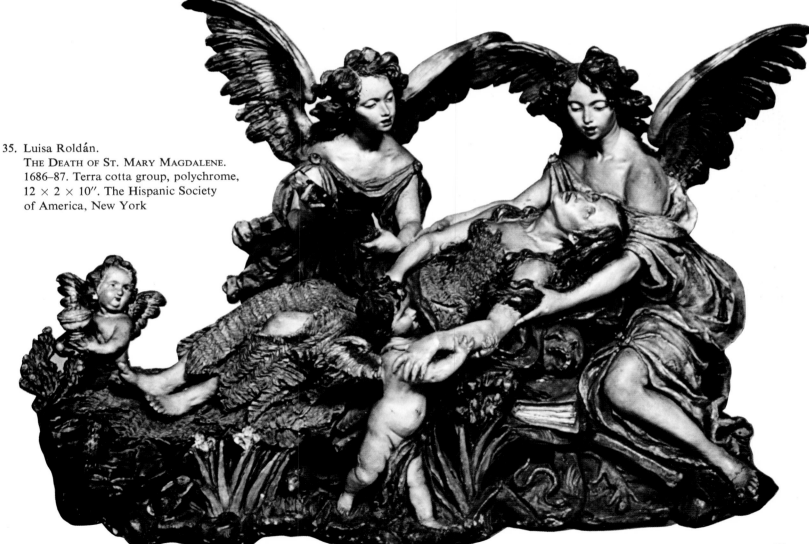

35. Luisa Roldán.
THE DEATH OF ST. MARY MAGDALENE.
1686–87. Terra cotta group, polychrome,
12 × 2 × 10″. The Hispanic Society
of America, New York

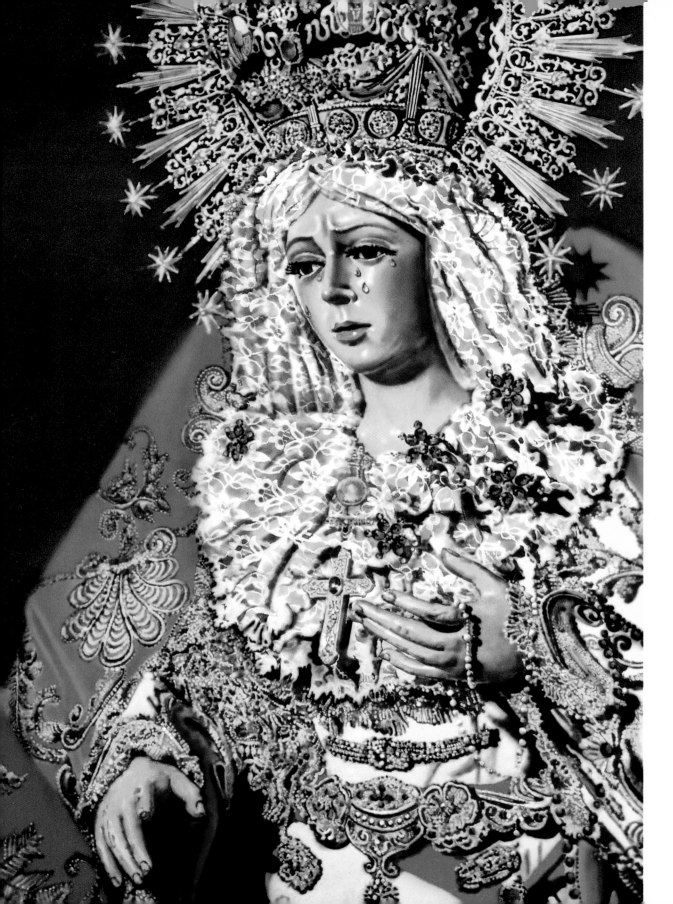

36. MACARENA OF MIRACLES. 1971.
 Oil on canvas, 66 × 46″.
 Metropolitan Museum
 of Art, New York.
 Gift of Paul F. Walters

37. Photograph of the MACARENA
 OF MIRACLES lithograph and Amy Zerner,
 dressed as the living
 sculpture in a happening, *In
 the Event of Living Sculpture,*
 O. K. Harris–Susan Caldwell
 Galleries, New York

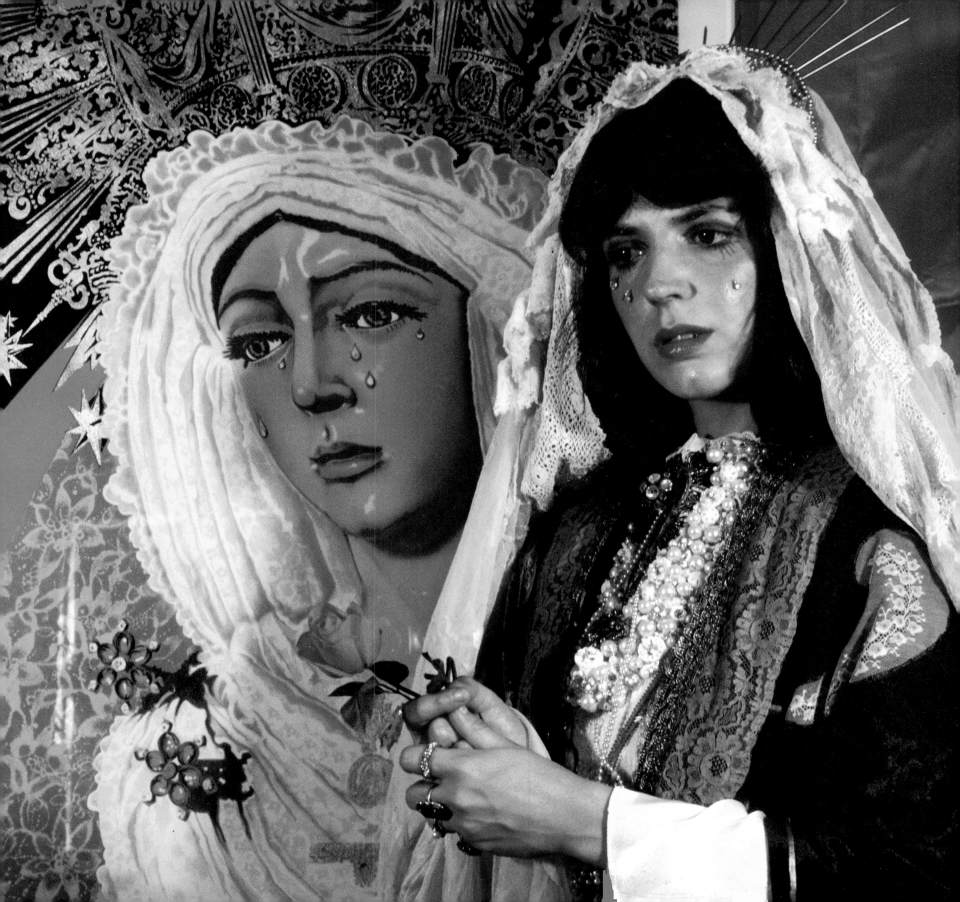

38. Lady Madonna. 1972.
Oil on canvas, 78 × 69″.
Whitney Museum
of American Art,
New York. Gift of
Martin J. Zimet

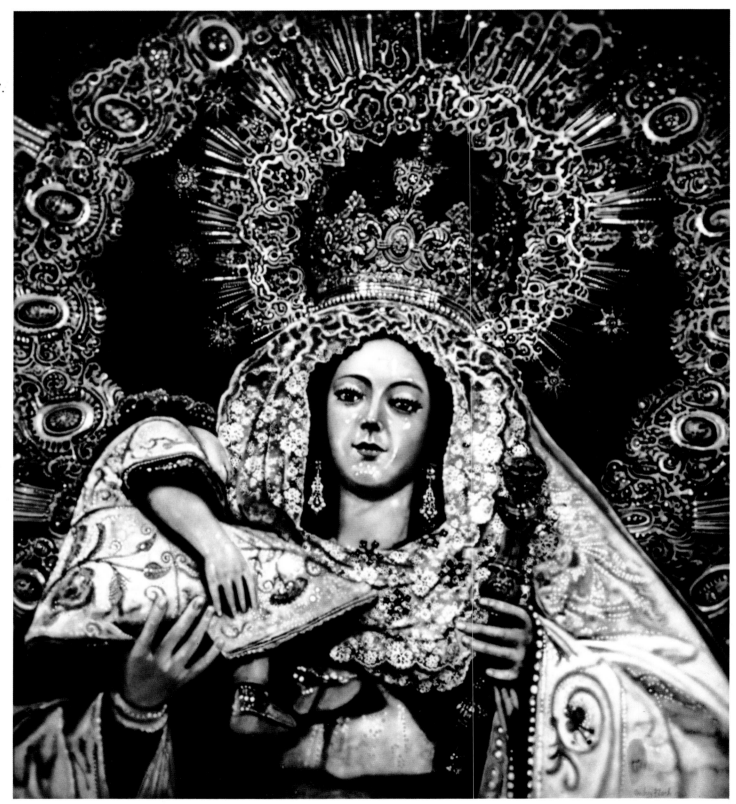

cross before her. A cherub at her feet holds a vase of ointment, her symbol. The angels' wings are alive and vibrant, polychromed in rainbow colors of red, yellow, blue, and gold. The faces of the angels are lovely. Blue and white flowers grow in front of the rocks. Indicative of the saints' lives of penance are a bloodstained scourge, a skull, and a book. A snake, lizard, owl, and rabbit add detail.

This work was thought to have been repainted, but it was not. La Roldana's terra-cottas were probably installed in glass cases to protect them, which most likely explains the lasting brilliance of the colors. They are sometimes referred to as garish, but I think they are marvelous.

My painting, *Macarena Esperanza,* depicts the original sculpture carved by La Roldana, the statue that is paraded through the streets of Seville during Holy Week. Surrounded by hundreds of lighted candles, she is adored, worshiped, and treasured. She is covered with diamonds, emeralds, lace, and gold—elaborately ornate, super Baroque, high kitsch. The carving and delicacy of the face are superb, the smooth and satiny polychromed skin, with pink cheeks and rouged lips, exquisite. But because of the kitsch additions of ornament, the statue has been ignored or ridiculed outside Spain. One of the things I wanted to do in my painting was to restore the *Macarena* to the level of high art, to bring her back into the realm of respected masterpieces. I wanted to do this without removing the ornamentation, and I have included every bit of drapery, lace, and gold, every jewel and chain. I believe these accessories have become part of the statue through the centuries and add to the radiance it emanates. It should be noted that the tears are very much a part of the original sculpture, typical of Spanish Baroque "passion" art.

Macarena of Miracles is another version of the *Macarena* I painted. It shows more of her body, her elaborate dress, jewels, and gold girdle with diamond studs. It also shows the glorious star-pointed crown of solid gold.

Because of my deep involvement with La Roldana, and because Spanish madonnas have had an effect on me, when I painted my own skin in my *Self-Portrait* I quite consciously eliminated the scars and imperfections on my cheeks and replaced them with the buttery, smooth surface of La Roldana's *Macarena,* transforming that surface into the polychromed skin I have always wanted.

39. Luisa Roldán. Virgin and Child. Terra cotta. Collection Don Fernando de Muguiro, Madrid

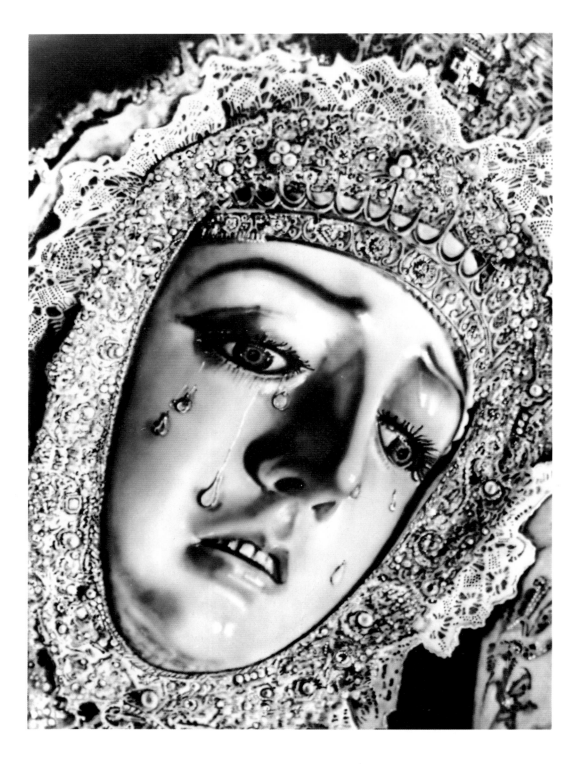

40. DOLORES OF CORDOBA. 1971.
Oil on canvas, 70 × 50″.
Private collection

41. SELF-PORTRAIT. 1974.
Acrylic on canvas, 80 × 64″.
Collection Marcus and Irene Kutter,
Basel, Switzerland

Color

Color does not exist in and of itself. All through my life as an artist, until I began to experiment with the air brush, I accepted color as a fact—something to be squeezed out of a tube and resupplied when the tube was empty. It could be a crayon, a pastel chalk, jars of Rich Art tempera, but always "color" was "color." "Cadmium Red" was a fact. I was well aware of the subtle differences between brands—Shiva Alizarin Crimson was oilier than Winsor Newton Alizarin. Winsor Newton Cadmium Red was richer than Grumbacher Cadmium Red. My concept was that color was a material substance. It is not!

Color should be thought of in terms of light. Webster's dictionary says that color is "the sensation resulting from stimulation of the retina of the eye by light waves of certain lengths." My definition of color is: "Color is created by light waves of various lengths hitting a particular surface. The surface may be absorbent, reflective, textured, or smooth. Each surface will affect the wave lengths differently and thereby create different colors. These wave lengths will affect the retina, and the eye will perceive color."

Each color has its own wave length, or better still, each wave length has its own color. The light which Newton separated into seven distinct colors with individual wave lengths is called a spectrum—red, orange, yellow, green, blue, indigo, violet. Light travels at 186,000 miles per second in wave lengths and as it travels it *vibrates*. It is these reflective rays or vibrations we perceive as color. Color does not exist in and of itself. Objects themselves are colorless. They appear to be colored because they absorb certain wave lengths and reflect others. In 1969, while analyzing a projected slide on a white, smoothly sanded canvas, I noticed that what appeared to be color really was dots of red, yellow, and blue, mingled together to produce all other shades. Nowhere was there a flat opaque mass of color; rather, there were dots or globules which gave the effect of color. As I stood in my semi-darkened studio I realized that all of this color was being produced by a single light (250-watt halogen bulb) being projected through a gelatinous slide. Without the light there would be no color. Physicists use the term "excited." They say color becomes excited by light. Color is not stable, it changes as light changes . . . daylight . . . bluish light . . . sunlight . . . moonlight . . . neon light . . . bright light

42. CRAYOLA. 1972–73.
Oil over acrylic on canvas, 36 × 50″.
Private collection

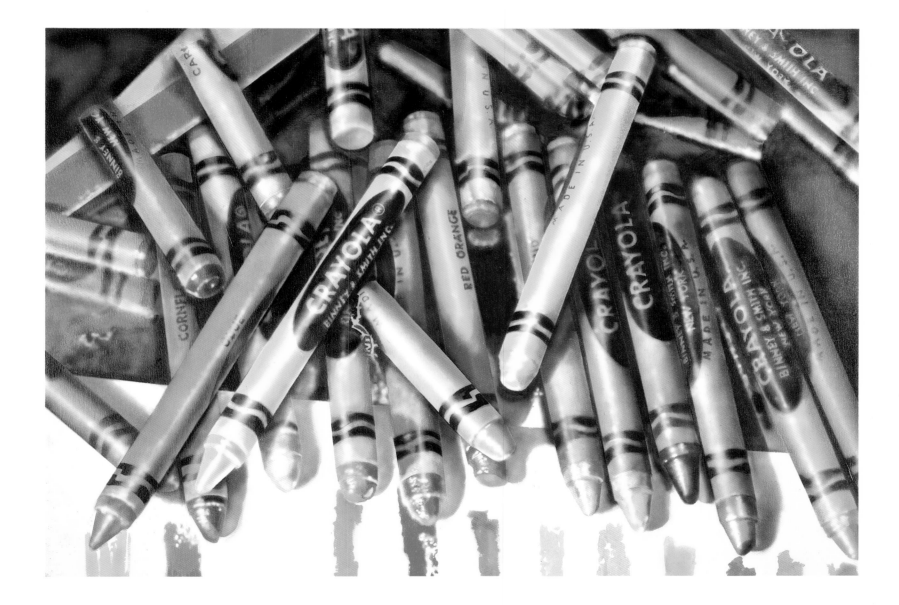

. . . half shade . . . darkened room . . . hazy or misty light . . . clear filtered light, and so on. It is chameleon-like, changing with the properties of light.

Black is fascinating in that it contains greater amounts of reflected light than many light colors. There is much white in black. Velázquez knew this and used it in painting the terraced skirt of the Infanta. When I painted *Davey Moore* and *Two Women Grieving Over Kennedy Outside a Dallas Hospital* I began to deal with color as reflected light on black and brown skin. The day I started work on *Davey Moore* I picked up my tube of Winsor Newton "flesh tint" to mix colors for his skin . . . what a shock! That tint was for my skin, not his. Dark-skinned people usually do not have pink cheeks, and they reflect more white than white (pink) people.

When I began working with the air brush, I realized that spraying—Cadmium Red light, for instance—produces a completely different color than applying it with a brush. Spraying produces small beads of color and the density of the application affects the intensity of the color.

No matter how densely I sprayed the surface, it still appeared different from the painted Cadmium Red light. Both were acrylic, both were applied to a similar surface, but the air-brushed paint appeared foamy, lighter, smoother, and alive in another way. Yet the colors came from the same jar of paint. Light was reflecting differently when bounced off thousands of tiny particles than off a brush-painted surface.

Compare the brilliance of a slide with the opacity of a photograph. The photograph is dull in comparison. I wanted to make a painting as luminous as a color slide. I had to deal with light in order to accomplish that.

Color depends on a myriad of surrounding conditions. Whether the surface is smooth or rough, absorbent or reflective, what kind of air brush—tip or needle . . . what kind of paint brush—sable or bristle . . . what kind of pigment— oil or acrylic, gouache, pastel, watercolor, crayon, pencil, etc. . . . what kind of light . . . and whose eyes—for ultimately we all perceive color differently. What we hope for is an acting norm within a certain range for comparison purposes.

When visible light is refracted we get a rainbow ranging from short wave lengths to long wave lengths—violet, indigo, blue, green, yellow, orange, red. This field of energy is all

43. RICH ART. 1972–73. Oil over acrylic on canvas, 36 × 50″. Private collection

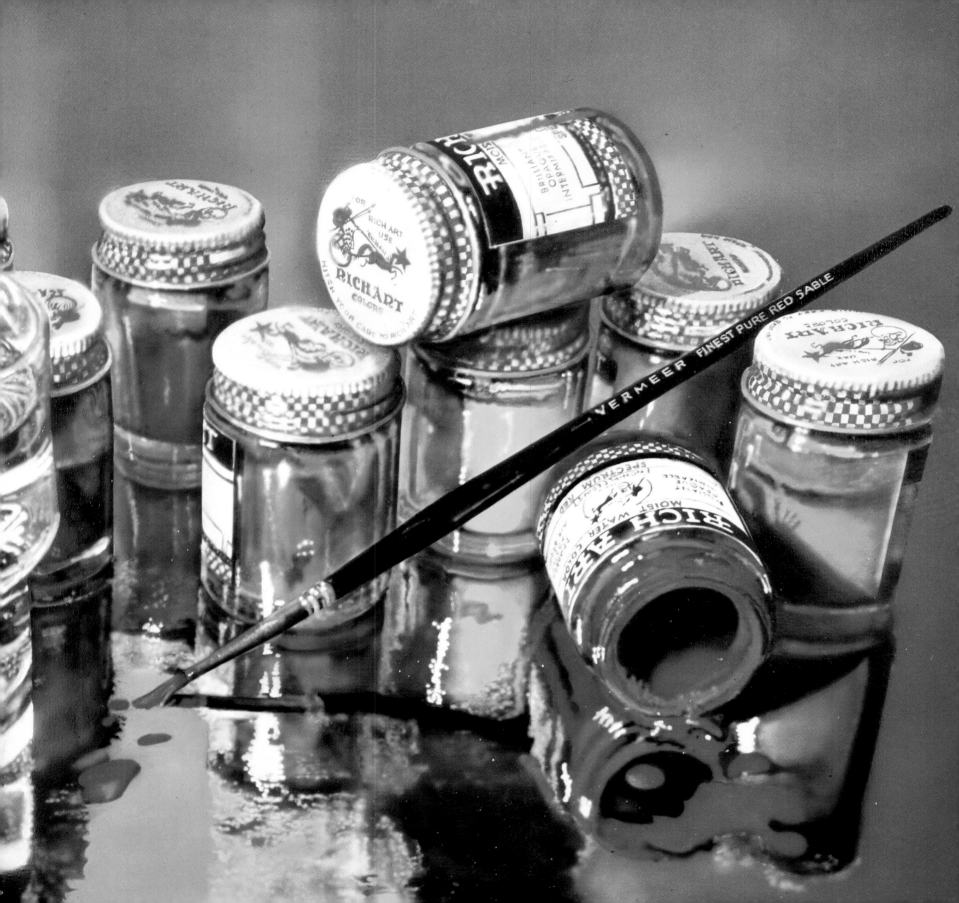

44. SHIVA BLUE. 1972–73.
Oil over acrylic on canvas, 36 × 50″.
Collection Dr. Jack E. Chachkes, New York

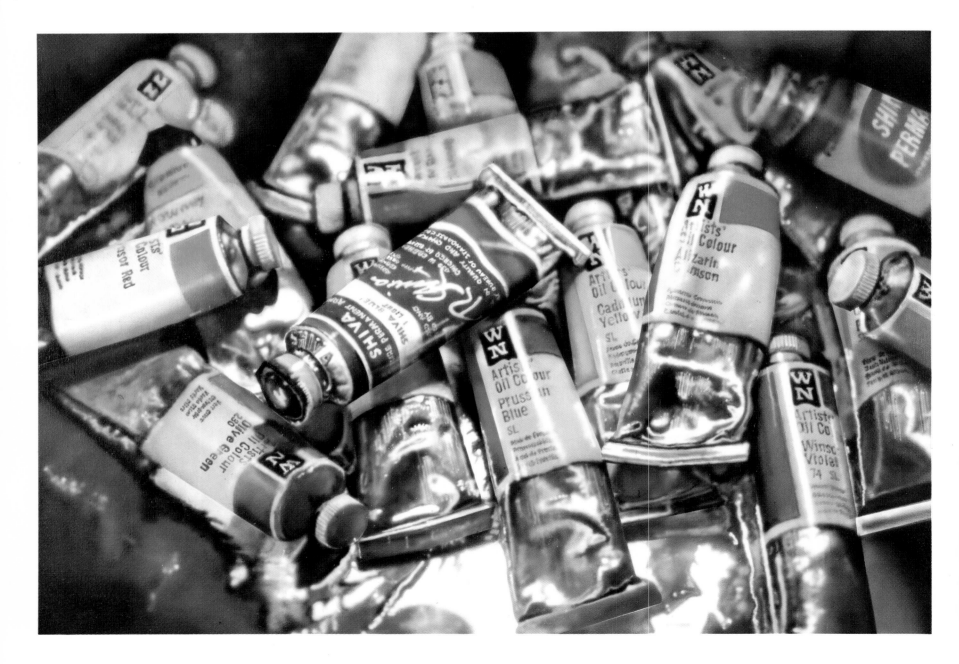

45. SPITFIRE. 1973.
Oil over acrylic on canvas, 70 × 96″.
Stuart M. Speiser Collection,
Smithsonian Institution, Washington, D.C.

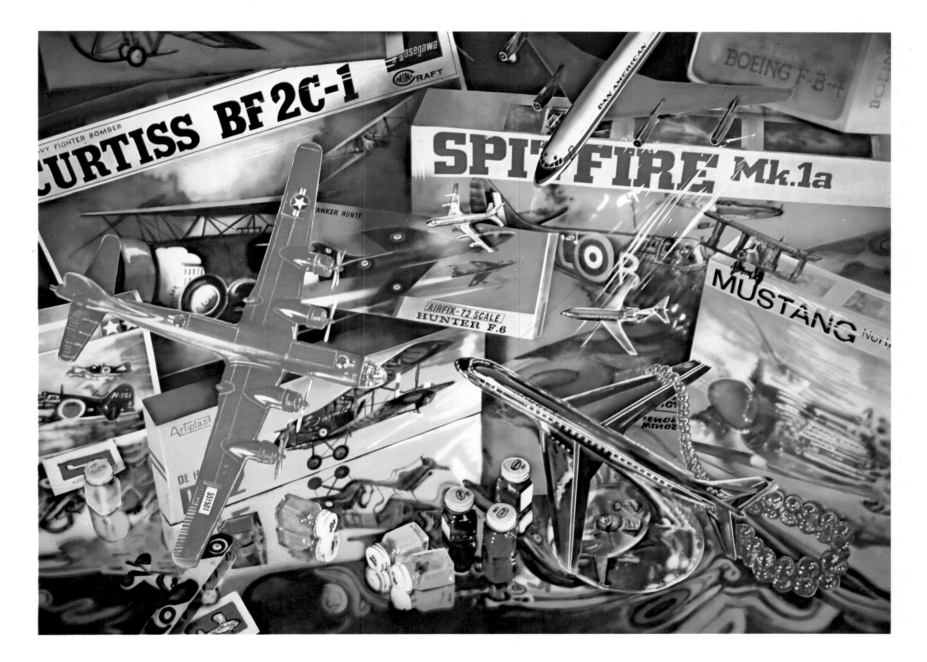

around us. What one perceives as a result of this energy is an illusion. Only the energy itself is real. Color does not exist in actuality. It is only a sensation in our consciousness.

When an artist selects a color, that pigment contains the potential of producing a particular wave length. When that pigment is applied to a surface, the wave length which is reflected back to our retina is perceived as color. It is *vibrating*, and we feel that vibration. When we look at a Raphael or a Piero della Francesca, the *Baptism of Christ*, for example, we are receiving the wave length of cool blues, muted gray whites and yellow whites, soft pinks rather than harsh reds. In Piero's *St. Michael* the sword tip is bathed in a soft pinkish red, whereas the same sword painted by Carlo Crivelli or Rubens would be virtually dripping with blazing red blood. These wave lengths are shorter and produce a calming and soothing effect. Classical artists tend to select these colors, and thereby produce more harmonious paintings than do Baroque artists. Rubens's palette contained brilliant reds, luminous oranges, golden yellows, colors that have longer wave lengths. Red has the longest, violet the shortest. This is a strong contributing factor to the vibrating excitement in his paintings.

We actually receive vibrations from paintings. These vibrations are emanating from colors. When we say we receive a charge from a work of art, it is not just psychological in nature. Physical properties are affecting us. My experiments with color, light, and the air brush affected the way I painted. I discovered that colors mixed in a dimly lit room under a spotlight, which when held up to the canvas matched exactly the projected image color, were between five and ten shades off in a room that was fully lit. I began to premix my colors, storing them in film containers and jars. My thought process gradually changed. I began thinking in terms of light rather than color. I would select a pigment and apply it to a surface which I knew would reflect light. Conversely, if I wanted a dark I would select a pigment with non-reflective qualities and apply it to an absorbent surface. In many cases the color of the pigment was secondary and I could pick any one of the many colors to achieve the desired effect.

Several paintings were made with a three-color process using Acra Violet, Cadmium Yellow, and Phthalocyanine Blue. I never used photographic color separations, for I could easily separate the colors in my mind.

Being concerned with the surface that light hits, I later established "base colors." These colors are a median tone and are applied as flat areas over which red, yellow, and blue are sprayed. Working in the three-color process I would have to spray Acra Violet from a great distance to get a pink. The dots of spray would necessarily have to be quite far apart. In the "base color" technique, I would apply a flat pink, over which I could create every nuance with red, yellow, and blue. The flat pink color is the equivalent of the surface of the skin. Light hits the surface of our skin and various shades are created—areas in shade, in full light, in semishade.

In the last phase of the painting I spray pure white light . . . highlights appear . . . the final bright light gets turned on.

I could underpaint base colors—for example, yellow and blue—and with Acra Violet in my air brush create a significant number of colors with one swoop of my air brush.

The red over yellow becomes orange (various shades), over the blue it becomes shades of violet and indigo. Phthalocyanine Blue over base yellow and red becomes all shades of greens, reds, violets. The entire spectrum is possible. The colors seem to get mixed in the air, but the final mix takes place on the canvas.

46. Photograph of the airbrush with paints and brush. Colors are stored in film containers and jars, making it possible to preserve specific mixtures for extended use

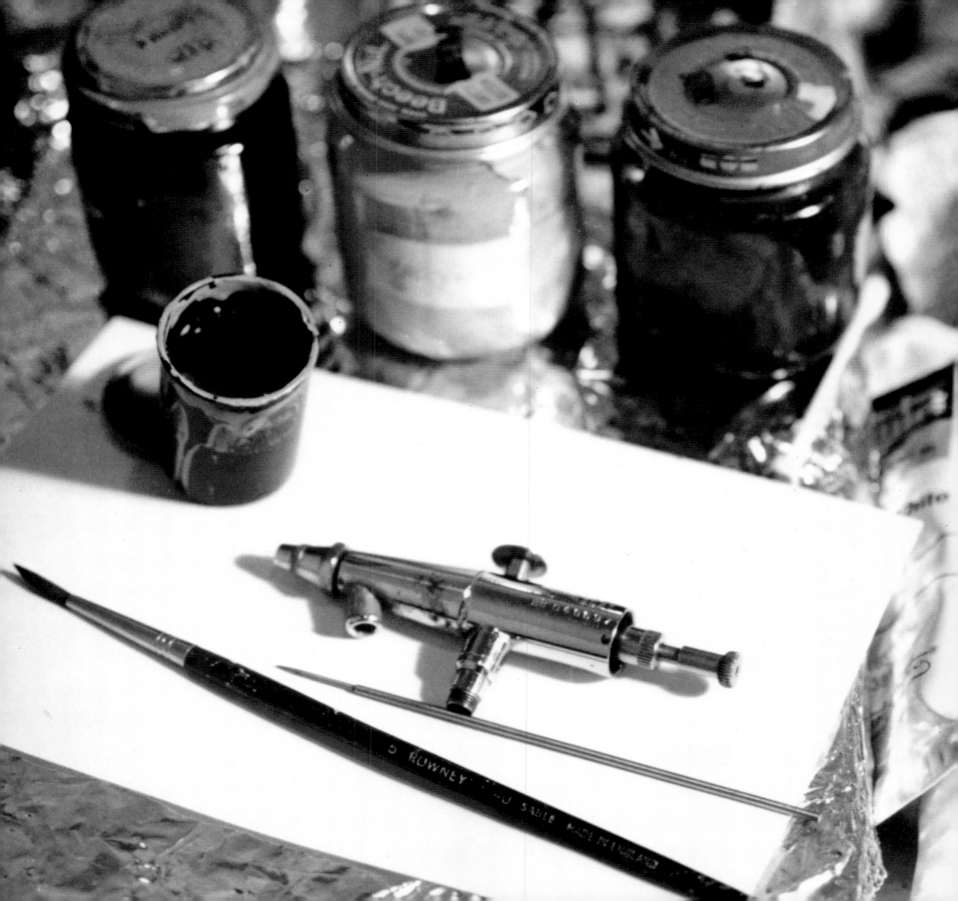

Line

I do not believe in the existence of line. There is no line in nature. I say this even though I love to draw, and have been a professor of anatomy. I draw with the knowledge that this too is an illusion. The history of vision is the history of losing line.

Artists are taught and perhaps naturally tend to make contour drawings. It is easier for the mind to isolate and silhouette an object it is struggling to see than to reproduce its rounded form on a two-dimensional surface. It is important to realize here that a silhouette is different from a line. A silhouette is the outer edge of a mass. It is mistakenly drawn as a line, but it is not a line at all. There is no line around an apple. An apple is a white mass covered with red or green skin. It takes its place in space. As in Archimedes' principle, it displaces air and uses up the space it needs. It is a solid form, a mass in space, rather than a line. A sculptor is less likely to perceive line, and more easily deals with form. The problem occurs in the translation from brain to paper, which is a two-dimensional surface.

In 1969 I was commissioned to paint the Farb family. As director of the Riverside Museum, Oriole Farb had put on some of the most avant-garde and exciting exhibitions in New York. I photographed the family, posing them in what I felt was the family balance. I started by drawing on canvas with charcoal, as was my usual practice. When I had completed three of the four figures, I became impatient, wanting to get beyond this stage and on with the painting. It also seemed a waste, since all of the charcoal lines would eventually be eliminated by being painted over. It was late at night and I suddenly had the idea of projecting an image onto the canvas. In this way I could place the figures rapidly and proceed with the painting. To this point I had only been working with the live models and with photographs. I owned no projector but was so excited by the idea that I called a friend who immediately responded to the urgency of my request. I projected the image. The figures I had already drawn were within a quarter inch of the projected image. I could scale easily

47. FARB FAMILY PORTRAIT. 1969–70. Oil on canvas, 40 × 60″. Rose Art Museum, Brandeis University, Waltham, Mass.

and never had the patience to work with a grid. A grid slowed the process for me and made painting too mechanical. There was a loss of excitement and vitality. I had been trained to have an Abstract Expressionist approach to the canvas.

This was the beginning. It opened up a new way of seeing and working. I started to paint directly with no preliminary drawing, thinking in terms of mass, volume, silhouette, and edge. It took a while for me to drop line altogether, but when it finally happened it allowed me a greater freedom and a direct contact with the canvas.

FAMILY PORTRAIT
1969-70
Audrey Flack

Royal Flush

Like Dostoevski, my family gambled—not casually, but with passion. For many years I sought to understand the nature and meaning of gambling. Gamblers use cards and dice to challenge the fates . . . the gods . . . the ultimate authority. Only a very few win. In their game of life almost all gamblers are losers. I made this painting with my family in mind, to present them with their ultimate fantasy . . . the highest winner of them all . . . the royal flush. It is not only for my family but for all of us, who from the moment we are born participate in the game of life. This painting uses the iconography of gambling to symbolize aspects of life.

The composition is circular—to be read as if one is participating in a poker game. Starting in the upper left-hand corner, one finds a pair of aces with the ace of spades on top, signifying the presence of death in our lives. Seen through a glass of Scotch, it appears partially distorted. The hand top center is a full house—three eights and two queens—which is usually a winner. A full house is a hand which holds three identical cards and one pair. One wonders about the origin of the symbolic phrase "full house." In this case it loses out to a better hand. Has this not happened to all of us, that when we think we have succeeded, another supersedes us? The player on the right has folded—turning cards over signifies withdrawing from the game. His hand was not good enough to compete. His cards are under a glass of beer which has become slightly flat, indicating the passage of time. A metal cigar holder rests atop two decks of boxed cards, pointing the way, along with some Chesterfield cigarettes, to the symbolic star of the painting—the royal flush—fanned out slightly below center.

A royal flush is the highest hand possible, the one chance in a million, the grand winner, the ultimate fantasy! I chose to show the royal flush in hearts, an overt allusion to love, for the winning here is not symbolic of money alone. To reaffirm the fantasy there are dice numbering seven resting on the flush cards. Seven is a winning number at the dice table if thrown on the first roll. After that it is a loser. Here it signifies a winner, that lucky throw. Someone has just sprung open the pocket watch to note the time, a cigarette is burning in the ash tray. The ice cubes melting in the glass of Scotch, the slightly flat beer, everything indicates that the game has been going on for hours . . . perhaps a lifetime . . . perhaps an eternity.

48. ROYAL FLUSH. 1973.
 Oil over acrylic on canvas, 70 × 96″.
 Private collection, Paris

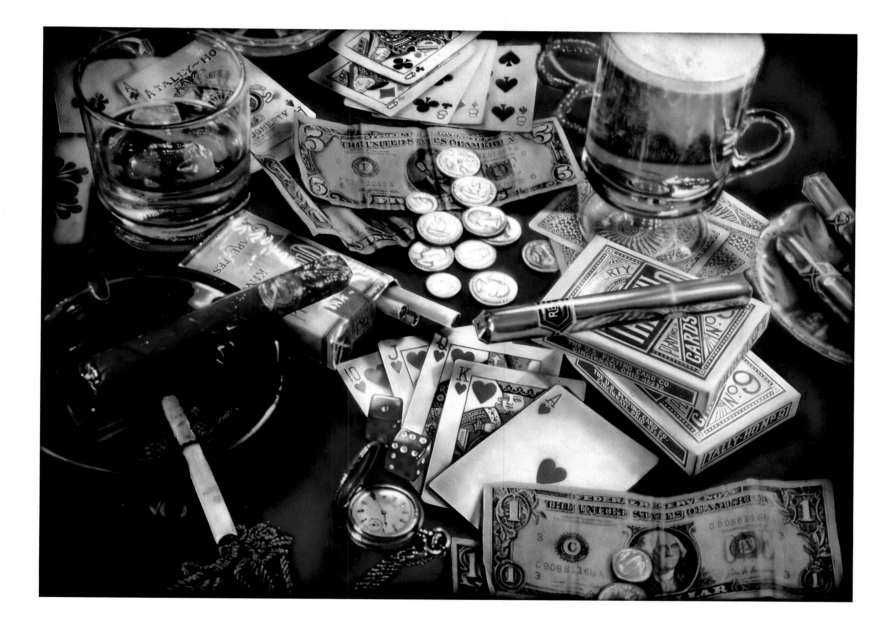

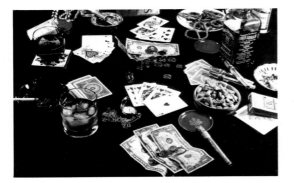
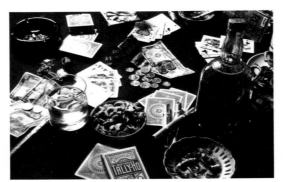
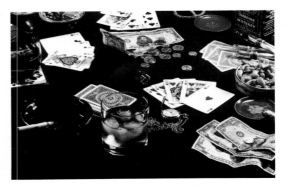
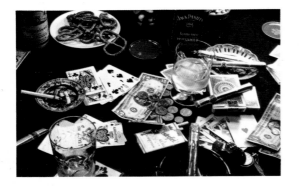
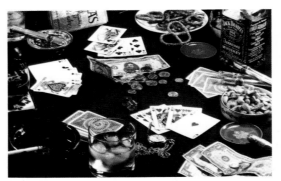
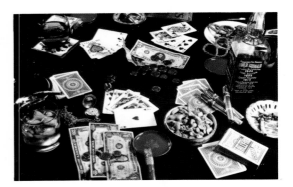
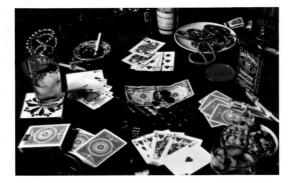
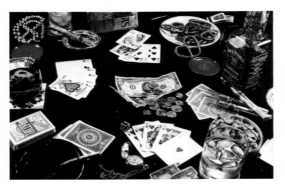
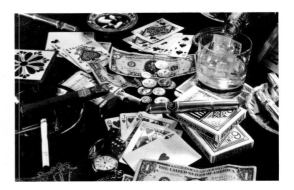

49–57. ROYAL FLUSH photographs.
Nine arrangements in the setting up
of the still life

56

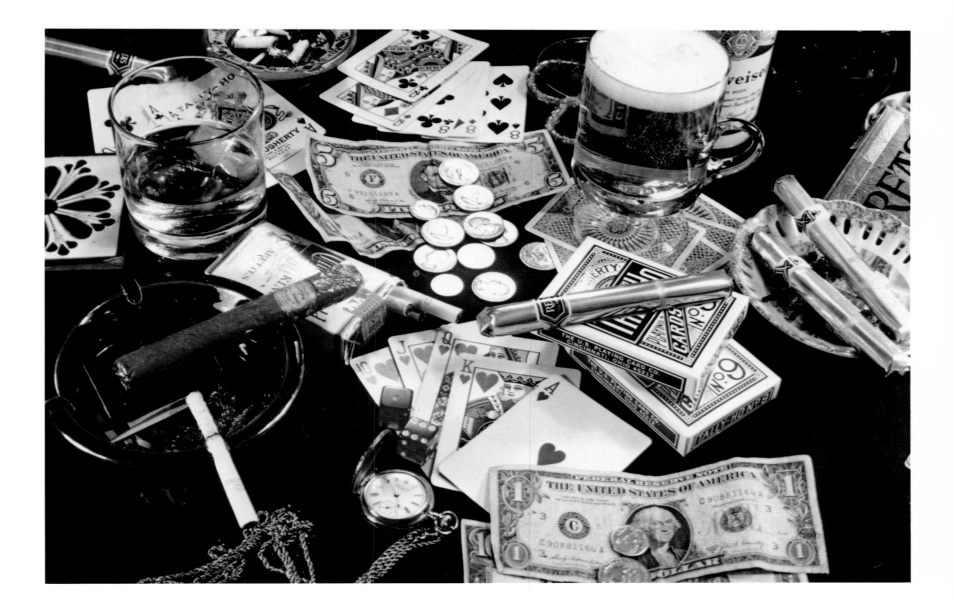

58. ROYAL FLUSH: the final slide

59. SOLITAIRE. 1974.
 Acrylic on canvas, 60 × 84″.
 Collection Joan and Barrie Damson, Harrison, New York

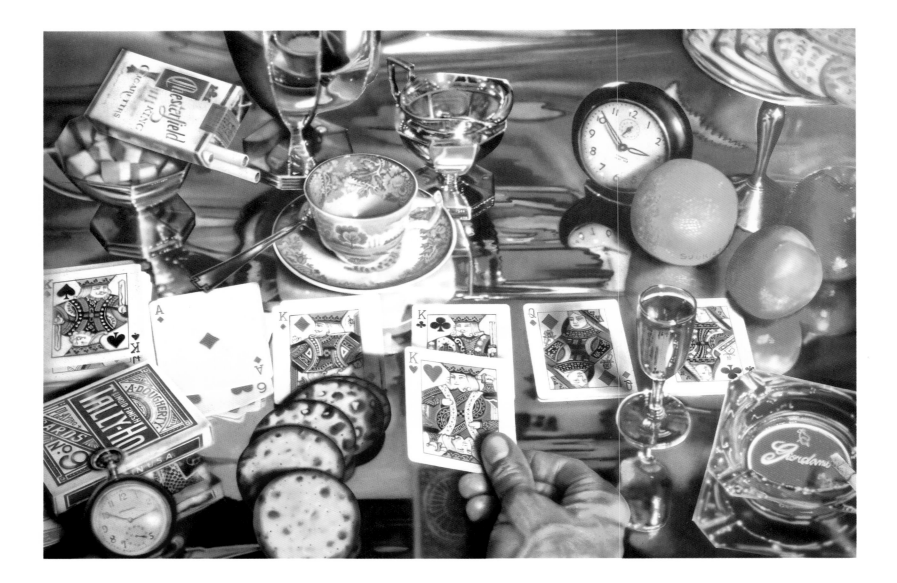

60. CHANEL. 1974.
Acrylic on canvas, 60 × 84″.
Collection Mr. and Mrs.
Morton G. Neumann, Chicago

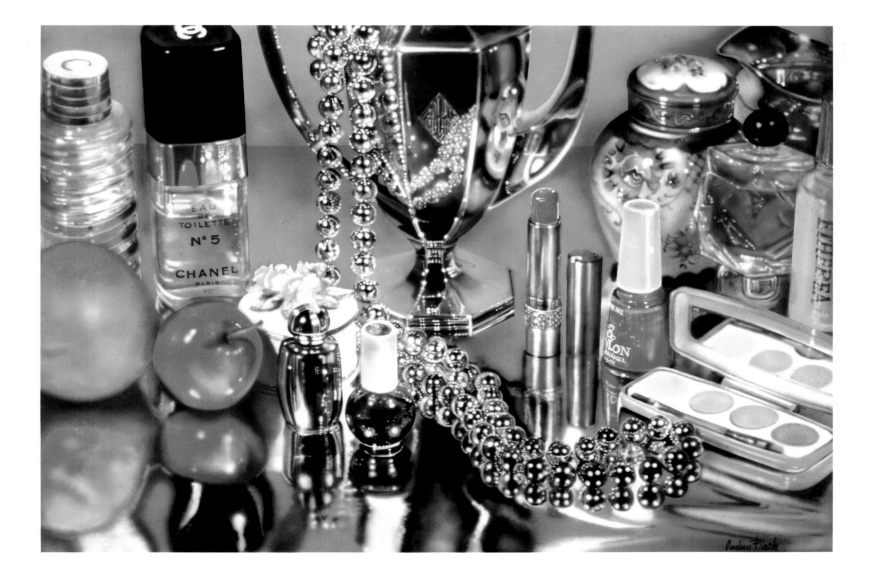

Gray Border Series

61. SPACED OUT APPLE. 1974.
Acrylic on canvas, 58 × 60 1/4″.
Collection Mr. and Mrs. Jerome Westheimer,
Ardmore, Okla.

The *Gray Border* series evolved over a period of two years. It has to do with my involvement with both space and light. The paintings served to expand my formal vocabulary. Questions of scale, of projection out from the picture plane and into the physical space of the viewer, strangely seemed to grow from my experiences as an Abstract Expressionist painter as well as from my excitement over Mannerist space devices.

I believe these paintings are more strongly connected to the more iconographic works that followed them than might be immediately apparent. The border itself changed to dark brown wood in *Gambler's Cabinet*, black with white stripes in *Dutch Still Life*, and symbolic black with a spectrum of color stripes around *World War II*.

The *Gray Border* series was becoming more abstract, less realistic, more involved with formal elements, "picture-making." Then the work did an about-face and got more involved than ever before with extremely complex narrative in the *Vanitas* series. Harold Bruder says the *Gray Border* series might be compared to an athlete's preparation to go on and run a marathon, that being the *Vanitas* paintings.

The gray border was created to establish a median plane and a median tone in order to measure space, depth, and light. A specific shade of gray was mixed for each painting to keep in balance with the tonality of that painting. In *Leonardo's Lady*, for example, I used a warm, almost tactilely soft grayed ocher, and in *Grand Rosé* the gray was much bluer and cooler. In every case, however, the gray was meant to be neutralized, neither the absence of light (black or dark brown) nor the presence of full light (yellow-white or pure white). Rather, that in-between presence of semidarkness, semilight—the color of the atmosphere sometime after the sun sets but before the black of evening falls—a transitional time.

The three-color process was used for the border of *Self-Portrait*. A balance of red, yellow, and blue will produce gray. I used a gray base tone plus red, yellow, and blue for the other paintings of the series.

When the gray border functions as *neutralized light*, I thought in terms of applying colors to project forward or to recede, the gray tone acting as a basis of judgment, a foil against which the colors and values of the objects could emerge. Red, yellow, blue, green, etc., always measured

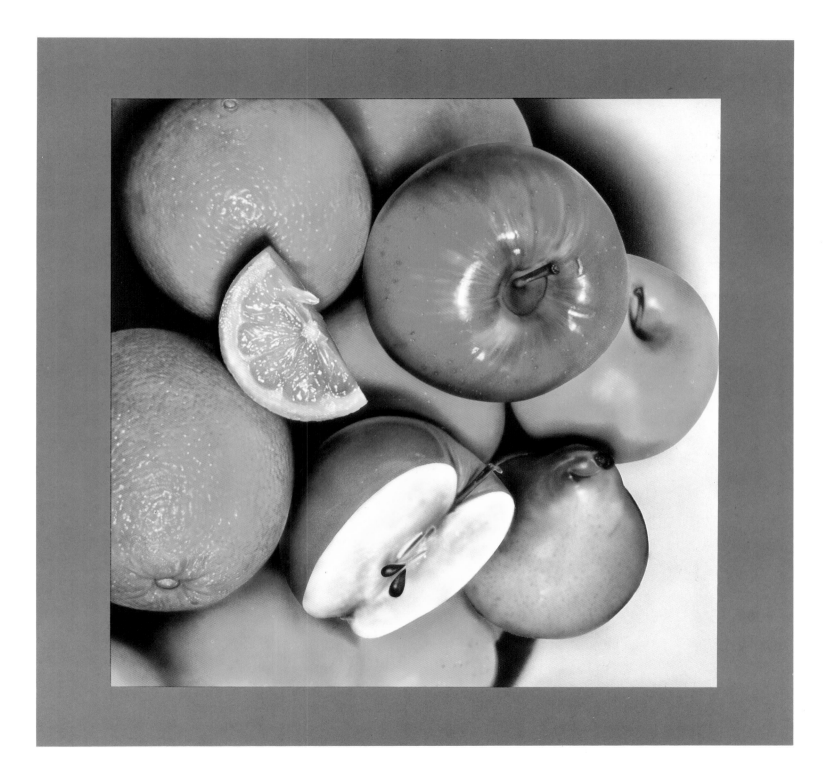

62. BUDDHA. 1975.
 Oil over acrylic on canvas, 70 × 96″.
 St. Louis Museum of Art, St. Louis, Mo.
 Purchase and Contemporary Art Society Fund

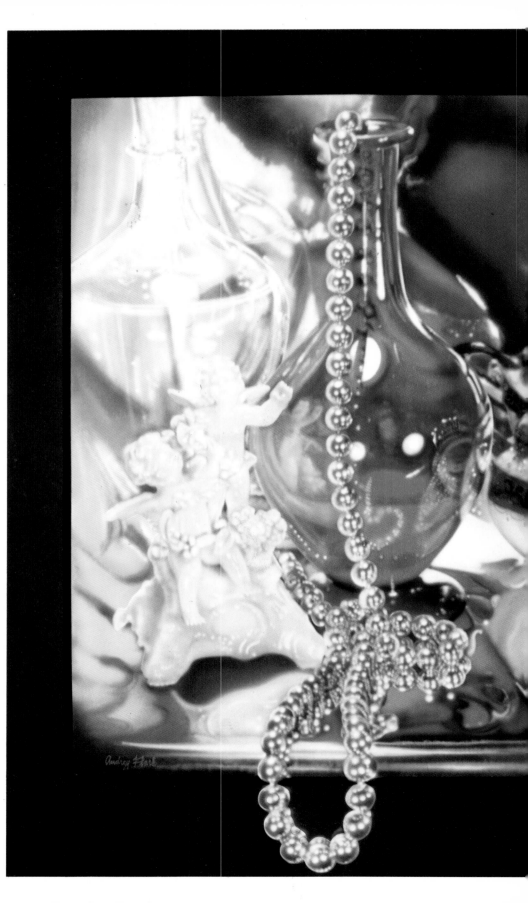

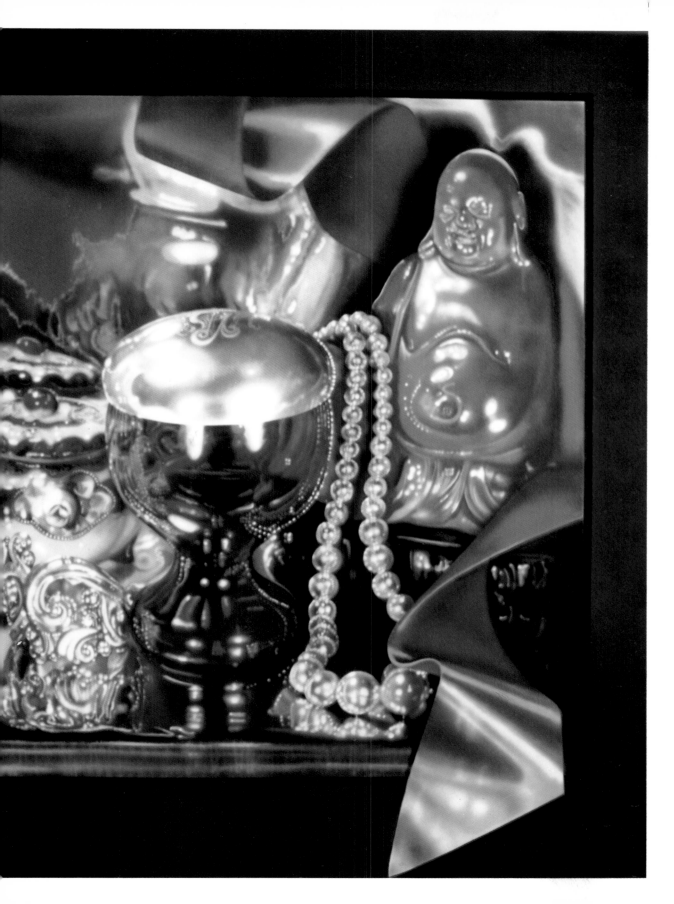

63. BUDDHA (in progress)

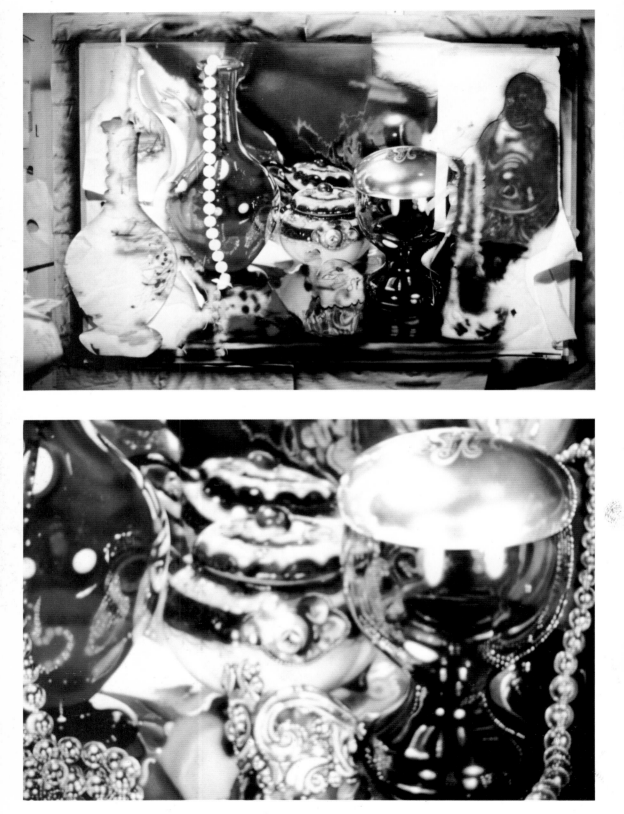

64. BUDDHA (detail)

65. BUDDHA (detail)

66. QUEEN (in progress)

67. QUEEN. 1975–76.
Acrylic on canvas, 80 × 80″.
Private collection

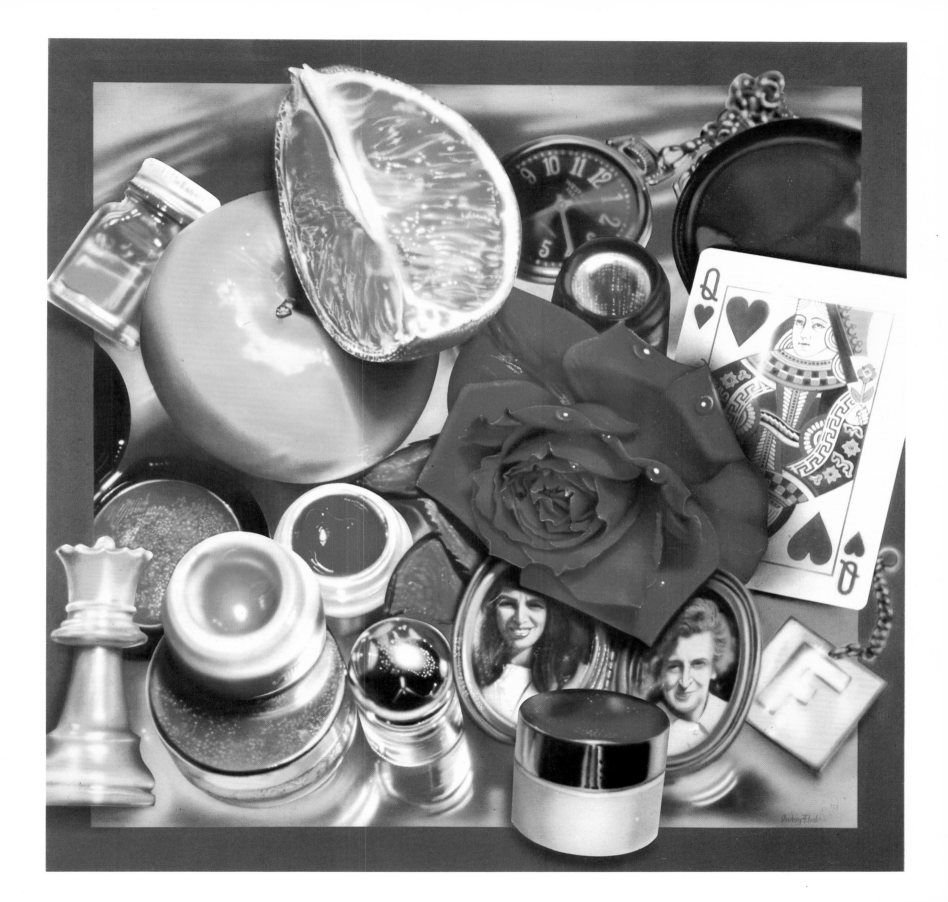

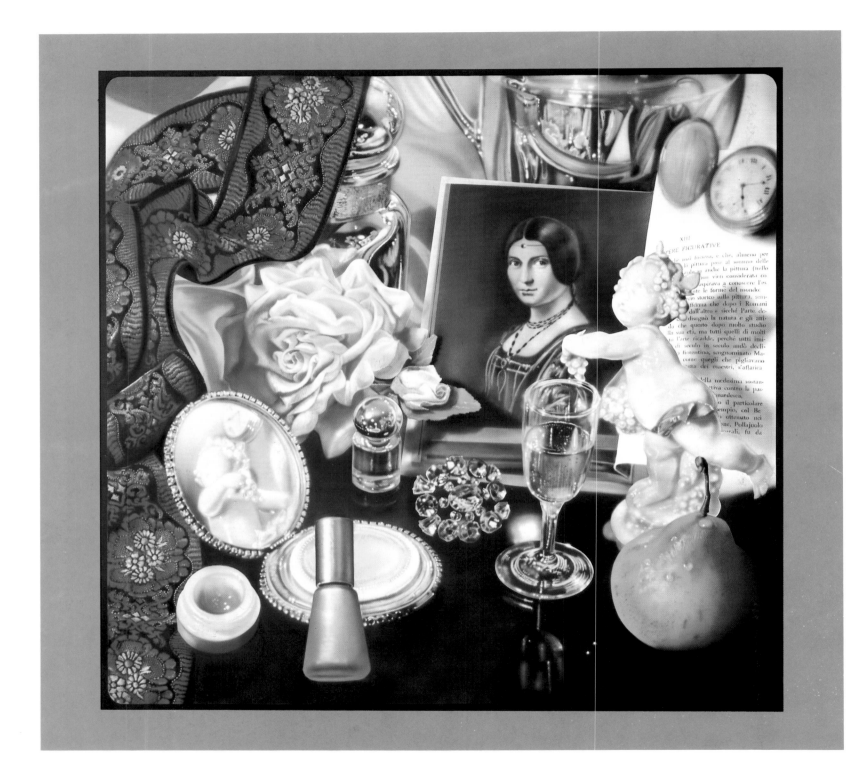

against a steady, noninterfering gray. Observers can always measure distances themselves by comparing the colors to the gray border.

The most important aspect of the series for me was space. It is difficult to separate space from color—they are so entwined and interdependent. Every color, receding or projecting forward, is attached to an object in the painting. Every object takes a specific position in the space of the painting. The picture plane is tilted up—sometimes slightly as in one of Cézanne's table tops, most often with the table top moving to the top of the canvas, sometimes disappearing altogether, establishing a picture plane parallel to the wall. It is not, however, a two-dimensional surface. The sanctity of the two-dimensional picture plane is violated. Objects are projected forward, breaking through the flatness of the vertical plane.

Jackson Pollock created a lacelike structure which established his vertical picture plane. The holes and spaces between the lace webs created a perception of "depth." He led us into an interstellar "space-depth" projecting inward *ad infinitum* and extending the picture beyond itself on all four sides. I was very involved with his use of space and depth and wrote a paper on it entitled "The Visual Change from Space to Depth" as my thesis at Yale in 1952. Much of my work at Yale, studying with Josef Albers, dealt with these problems of space and depth. I worked in an abstract style, painting over a grid. The grid's function was similar to Jackson Pollock's lace or my later gray border—it established a median plane.

In the *Gray Border* series I was dealing with volumetric objects I wanted to move backward and forward in space. The space in these paintings is measured, controlled, and finite. In *Spaced Out Apple* I inverted, reversed, and flopped the photograph in order to disorient the viewer, thereby intensifying his or her consciousness of space. Eventually objects began to float and appear to be lifting off the surface.

68. LEONARDO'S LADY. 1975.
Oil over acrylic on canvas, 74 × 80″.
The Museum of Modern Art,
New York. Purchased with funds
from the National Endowment for
the Arts and an anonymous donor

69. GRAND ROSÉ in the studio,
with airbrush and compressor.
The gray border is masked,
but one section was
peeled back to aid in
color reference

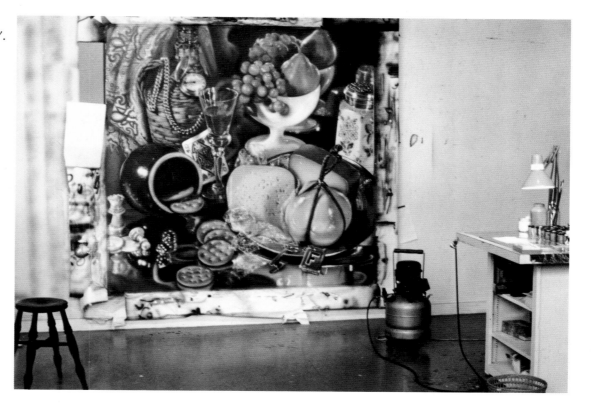

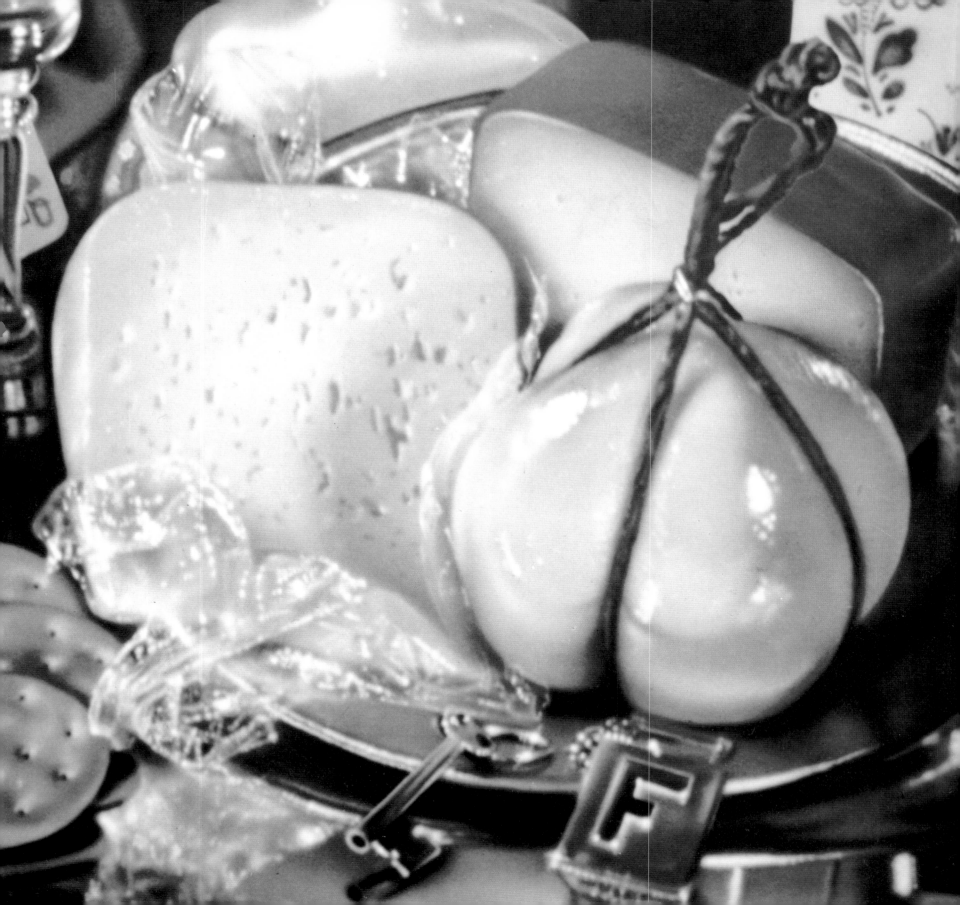

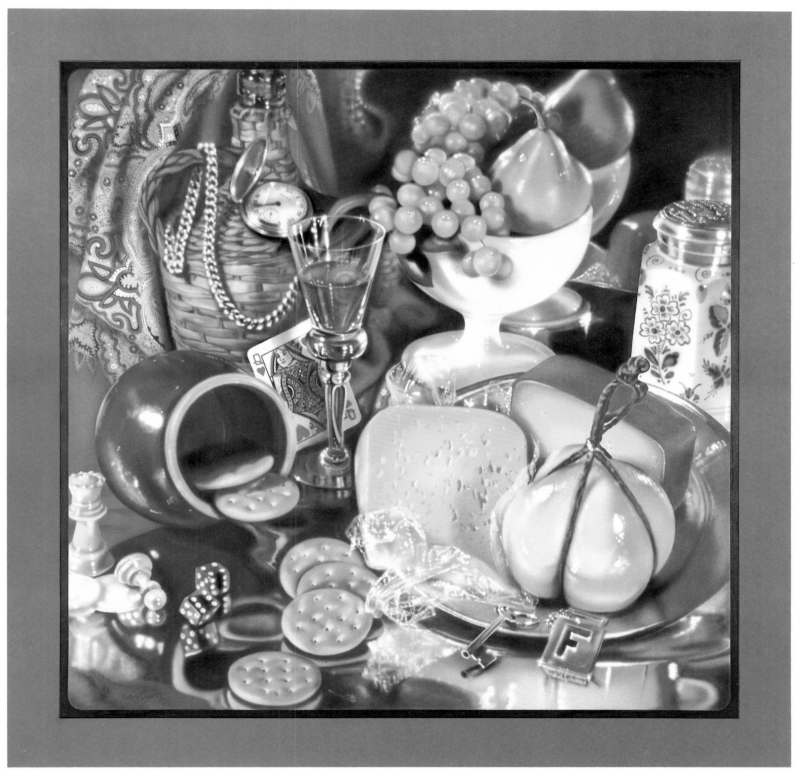

70. GRAND ROSÉ. (detail)

71. GRAND ROSÉ. 1975.
Acrylic on canvas, 90 × 90″.
Private collection

72. STRAWBERRY TART SUPREME. 1974. Oil over acrylic on canvas, 54 × 60 1/4″.
Allen Memorial Art Museum, Oberlin College, Ohio.
National Endownment for the Art Museum Purchase Plan

73. DUTCH STILL LIFE. 1976. Acrylic on canvas, 60 × 60″
The Solomon R. Guggenheim Museum, New York

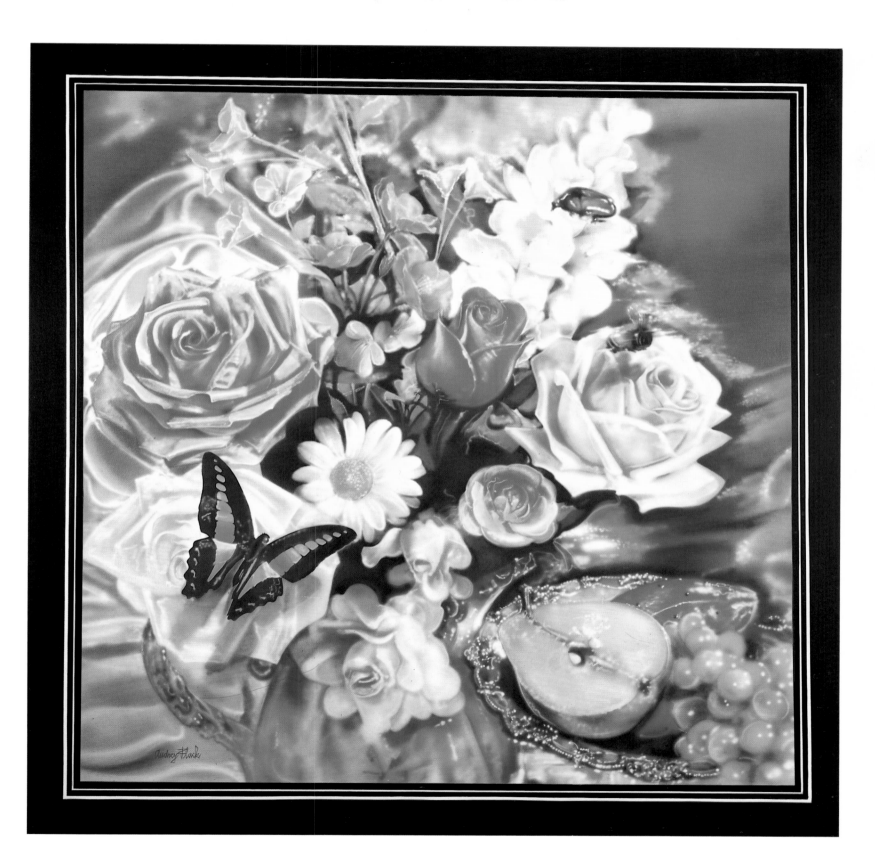

74. Gambler's Cabinet photograph.
An early stage in
arranging the still life

75. Gambler's Cabinet. 1976.
Oil over acrylic on canvas,
78 × 78″. Collection Louis
and Susan Meisel, New York

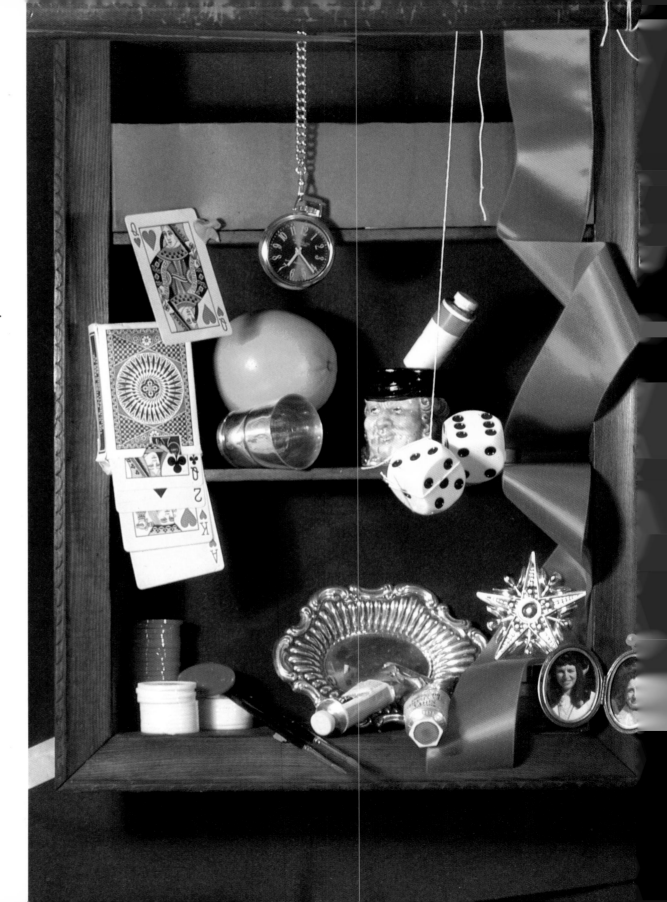

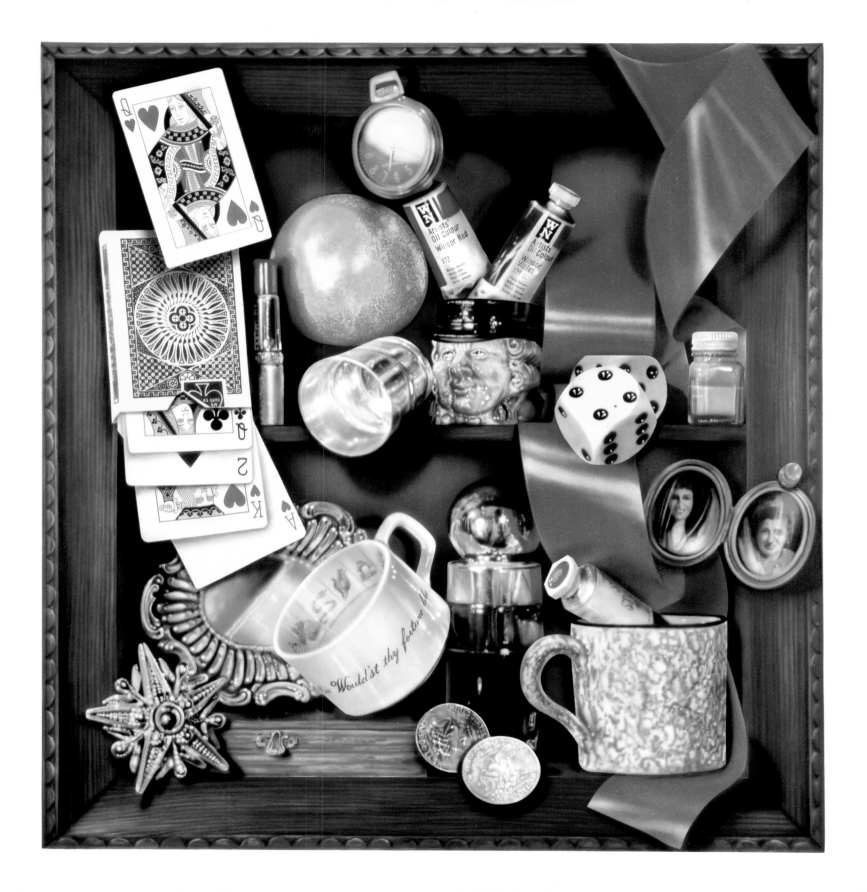

Vanitas – Communication and Modernism

The *Vanitas* is a form of painting which was popular in the seventeenth century and refers to the temporality of life. The word comes from the first chapter of Ecclesiastes: "Vanity of vanities, saith the Preacher, vanity of vanities, all is vanity. What profit hath a man of all his labour which he taketh under the sun? One generation passeth away, and another generation cometh: but the earth abideth forever."

We can have wealth, great beauty, and material pleasures, but eventually we all must die. The king, the queen, the rich, the poor, the priest, the layman, the lawyer, the doctor. *Vanitas* paintings encourage the viewer to think about the meaning and purpose of life. They have long been a favorite of still-life painters, who have used a variety of objects to symbolize their thoughts: an hourglass, a burning candle, or a watch, each signifying the passage of time.

I found myself using the *Vanitas* form in both old and new ways to communicate with the viewer and to express my views on life. When I began the series, I had done no research on the subject and the objects I arrived at came from my own mind after months of deep consideration. What amazed me later was that many of the symbols I chose were identical to those used by the Renaissance masters. This has reinforced my belief in Jung's theory of the Universal Archetype and Collective Unconscious. It is as if these objects are part of a common store of symbols available throughout history. An important aspect of art is communication. This idea has been cast aside by much modernist thought, which has emphasized "Art for Art's Sake" and has disregarded the popular audience, leaving it to "commercial" artists.

The modernist attitude is that the public must be *educated to understand art*. It has thus followed that museums have taken on the role of public educators, attempting to uplift a bruised and art-shy audience. This has intimidated many highly intelligent minds who, when confronted with an abstract canvas, say: "I don't know anything about art" ("but I know what I like" usually added shamefacedly). They have lost faith in their ability to tell good art from bad—whether it be abstract or realistic—and have accepted their "ignorance" as fact.

As as art student at Cooper Union, I was educated as an abstract artist. I knew the Abstract Expressionist painters. I painted in that style and would meet with many of them

at the Cedar Bar and the "Club," a meeting place set up by the artists themselves. Pollock, De Kooning, and Kline were my masters and I am still indebted to them and involved with their work. These painters were passionate and involved with *expressing* themselves *abstractly*. It was post-Abstract Expressionist modernism that advocated a cool unemotionalism and an elitist decorativism. John Perreault discussed this in the *Soho Weekly News*, Sept. 20, 1979: "Representational art is often seen as too accessible, but we all know this to be an offensive, elitist argument. . . . I am afraid that the real fear on the part of the so-called modernists is a fear of content. The content of abstract art, when and if this is achieved, is fairly arcane, whereas figurative art usually exhibits overt content and is therefore threatening and/or offensive to sensibilities that prefer Board Room art and Bank Vault art—high-class arrangements of pure color that form the machine-like expressions of social passivity."

I approve of sentiment, nostalgia, and emotion (three heretical words for modernism). I collect Spanish Baroque "passion" art. I use *Vanitas* symbols in order to increase communication on both conscious and unconscious levels.

I saw the *Vanitas* series as the most important paintings of my career, major works. The modernist establishment did not seem to comprehend what I was trying to do. The question of taste has constantly been raised in relation to my work. Somehow the attacks seem related to my background and my personal life as they are reflected in my art.

The problem seems to be that I am involved with life, trying to reveal the human condition as it has touched me rather than adjust to some establishment criteria. The questions are: What is taste? Whose standards do we use? Who sets those standards, and who publicizes them? Why has my work upset the modernist mainstream, when the public is so overwhelmingly responsive?

A painting has its own power and its own life. It exists in time, an expanse which is far longer than our lifetime. A great work of art lives on, it takes on dimension, it has its own lifespan. It can have many births and many deaths, not just the birth the artist gives it. It gets born again when it goes out into the world, it gets buried—sometimes for thousands of years—and then resurrected. But the truly great works of art outlast all and shine through the murk of stylistic changes. Vermeer was virtually unknown for a hundred years. The Spanish Baroque sculptors have still not been recognized. Carlo Crivelli has been both ignored and maligned.

Bernini predicted that his reputation would diminish after his death. He realized his work, which was involved with expressing emotion, would not be well received during the Age of Reason that was rapidly approaching. John Ruskin said contemptuously of Bernini: "It is impossible for false taste and bad feeling to sink lower." Robert Wallace in *The World of Bernini* writes: "Baroque 'exaggeration' jostles that staid Anglo-Saxon idea that understatement in esthetic matters is best. To some like Ruskin and Croce, the Baroque seems insincere or even hypocritical, and to others it seems hackneyed. To be properly persuasive it was necessary for Baroque artists to speak in terms that were used and understood by ordinary men. It was also necessary to touch their emotions. It is only through emotion, not dry reason, that most men can be persuaded."

I remember an ad which appeared in every major art magazine and newspaper all through my youth, and only vanished recently. It showed a Bouguereau painting, a nymph in a storm, and opposite it was Picasso's *Woman in the Mirror*. The caption, in bold black type, read: "Which is the work of Art?"

World War II

Outwardly they may have looked plagued by the misery and humiliation in which they lived, but inwardly they bore the rich sorrow of the world and the noble vision of redemption for all men and all beings. For man is not alone in the world. "Despair does not exist at all," said Rabbi Nahman of Bratzlav, a hasidic leader. "Do not fear, dear child, God is with you, in you, around you. Even in the Nethermost Pit one can try to come closer to God." The word "bad" never came to their lips. Disasters did not frighten them. "You can take everything from me—the pillow from under my head, my house—but you cannot take God from my heart."

Roman Vishniac, *Polish Jews,* New York, Schocken Books, 1976

76. WORLD WAR II (VANITAS). 1976–77.
Oil over acrylic on canvas, 96 × 96".
Collection the artist

My idea was to tell a story, an allegory of war . . . of life . . . the ultimate breakdown of humanity . . . the Nazis. After reading *Dawn and Night* by Elie Wiesel and *The Survivors* by Terrence Des Pres I was convinced of the existence of pure evil as well as the existence of beautiful humanity as exhibited by many of the survivors of the concentration camps.

I wanted to create a work of violent contrasts, of good and evil. Could there be a more violent contrast than that? I decided to use a Margaret Bourke-White photograph of the Liberation of Buchenwald. The prisoners in their striped uniforms—hollow faces—stunned beyond expression as an example of Nazi brutality. I chose specifically not to show blood or injury. Too much blood has been shed already. I did not want to capture the audience that way. But I wanted to shock. I did this by contrasting the image of the survivors with the sickeningly sweet pastries. I found a quote from a Hasidic rabbi in Roman Vishniac's book *Polish Jews* that deeply touched me. The innocence, the beauty and trust in God and humanity was overwhelming. I decided that would be a good contrast to the Bourke-White photograph, for the viewer could look at what happened to these people who could see, hear, and speak no evil.

I thought no viewer could stand to look at the true horror of the Holocaust if I graphically illustrated the blood, bones, crematoriums, operations, etc., in my Super-Realist style. One would have to cover one's eyes against the pain. Yet I had to get my message across somehow.

I also wanted to make a *beautiful* painting. Another contrast—beauty and horror. I wanted to seduce the viewer into the work and hold his attention long enough for him to read the quotation and then become involved with interpreting the symbolism. I am involved with the audience. I want them to become involved with the work. The silver dish with embossed roses, the lavishly flowing pearls, the sickeningly sweet petit fours are part of contemporary life—the vanity of the *Vanitas*. Offering still another contrast—opulence and deprivation. Many people were disturbed by the juxtaposition of the pastries with the starving prisoners. It was meant to raise consciousness but in many cases it raised guilt. Were we not all eating at that time? Are we not all eating now while

Buchenwald, April 1945

remarked: "If I thought that I should _____ hands on myself. But if I did not hope to be like the Gaon _____ en what I am."

Outwardly they may have looked plagued b_____ y and humiliation in which they _____ved, but inwardly they bore the rich sorrow of the _____ and the noble vision of redemption ___r all men and all beings. For man is not alone in the world. "Despair does not exist at ___ll," said Rabbi Nahman of Bratzlav, a hasidic leader: "Do not fear, dear child, God is with you, in you, around you. Even in the Nethermost Pit one can try to come closer to God." The word "bad" never came to their lips. Disasters did not frighten them. "You can take everything from me — the pillow from under my head, my house — but you cannot take God from my heart."

77. The artist with
 WORLD WAR II (in progress)

humans are starving elsewhere in the world? The human condition exists.

Conservative critics trained to accept paintings of worn boots or unwashed dishes in a sink have difficulty with my work. Impressionist still-life objects were permissible. Beads and pearls, silver and pastries were seen as a violation of the Post-Impressionist and Modernist code. I often wonder how they deal with seventeenth-century Dutch still-life paintings. Do they dismiss them because of their opulence, their fruit, jewels, silver urns, wine, food, drapery? I love these painters—Heda, De Heem, Rachel Ruysch, Maria van Oosterwyck, Claesz. I also love Cézanne, Van Gogh, Monet. I am more inclusive and a lover of multiplicity than exclusive and a minimalist.

Every figure was carefully painted, each expression was felt and translated. Upon comparing the photograph to the painting, it is interesting to see that they are not alike at all. There is something of me in those faces. I know, because I tried so hard to keep myself out and could not. It happened in the *Marilyn Monroe* painting. The face looks like Marilyn but I could not keep my feelings about her out, and when I looked at the painting after it was completed I saw that there was some tension in her forehead and some extra expression in her eyes that were not in the original photograph. It must have come from me.

I wrapped the painting in a red drape. I wanted it to look fiery. The pocket watch reads a few minutes before twelve. Minutes before the final hour . . . the witching hour . . . Walpurgis Night. The blue jar represents the cup of sorrows—reflecting the prisoners in abstract distortions in its silver cover. The inmates are painted in black and white, signifying time past . . . despair . . . memory receding in space, offering contrast to the brilliant Kodachrome of the present.

I looked for butterflies for weeks. I had to have a blue one, and it was not easy to find. I felt it was absolutely necessary for the painting. I invented a way to soften the butterfly wings in order to bend without breaking them. This took two days and delayed the shooting and increased my frustration. In my later readings on symbolism I found out that the butterfly represents the liberation of the soul, like the Holy Ghost or the dove of Christ. I also read subsequently that hundreds of butterflies alighted on Auschwitz years after the Holocaust.

After hours of work, Jeanne Hamilton and I had the *World War II* setup ready for shooting. We loaded the cameras, positioned the tripods, switched on the lights, and lit the tall red candle in the center of the still life. The candle was precariously tilted, resting on a piece of clay in order to give it the angle I wanted. It was leaning over the Roman Vishniac book with the Hasidic quote. It was to be a memorial candle—to bridge time between 1945 and the present, to burn always in the painting. We photographed first with the Nikon, a couple of rolls of Ektachrome, and then went on to the Hasselblad, my favorite camera. At that point the hot lights had begun to affect the candle. I looked through my lens and exclaimed to Jeanne, "My God, the candle is bleeding." The tilt we had given the candle made the red wax drip all over the book and it looked very much like flowing blood. At one point the shape of the melted wax looked like Hebrew letters. The candle was burning down rapidly and Jeanne and I shot at breakneck speed—it was an alive and thrilling time.

The border of *World War II* is a further extension of the *Gray Border* series. The mathematical proportion of each two of the rainbow-colored stripes equals one green. The rainbow border signifies all that is beyond the spheres, the afterlife, the refraction of all light and knowledge. The black border signifies the enclosure of the present and the expansion outside space and time—a memoriam. The piece of charred music is music of the spheres, its melody flowing through all time.

I felt it necessary to use brilliant Kodachrome-type color to reach a contemporary audience. These colors have permeated the modern vision, they are part of our society. Colors have power, they give off vibrations. I used powerful colors, powerful juxtapositions. Many people felt the vibrational waves of these colors. Many were upset, many went beyond. To me these colors equalled the enormity of the subject. Had I painted super-realistically the actual mutilations, these colors could not have been used—the horror would have been too strong. I wanted the ultimate beauty of the painting to surpass the subject matter. I wanted to use a rainbow with a Holocaust.

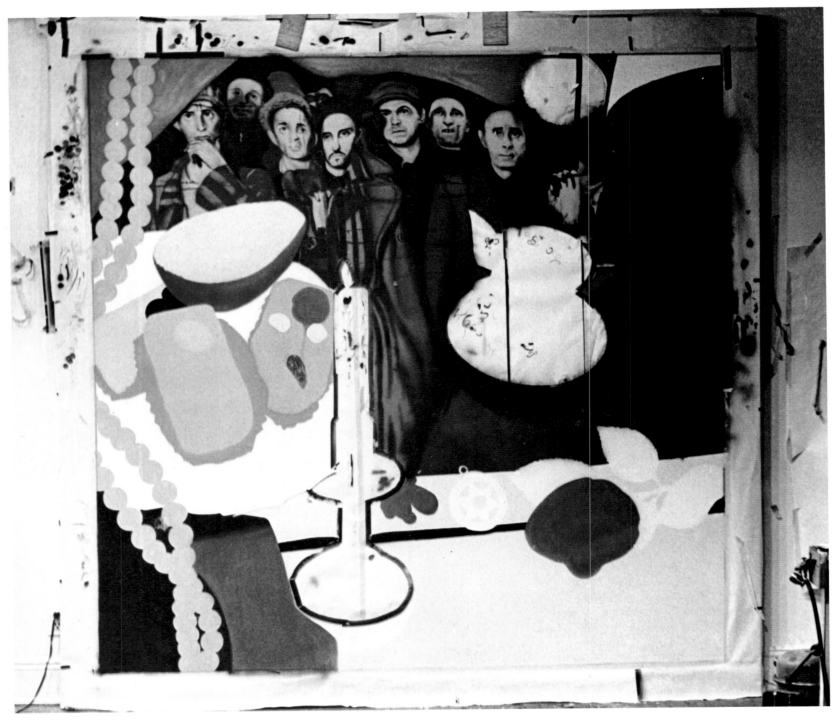

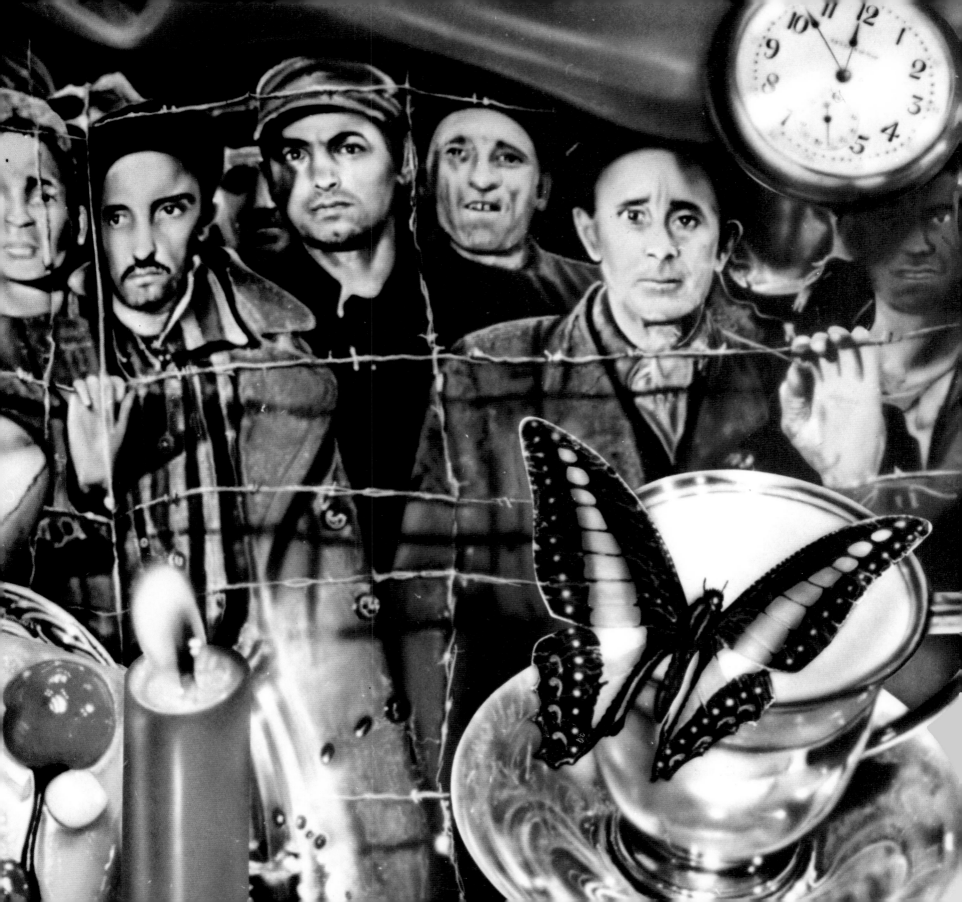

Marilyn

Marilyn Monroe is a universal symbol. She was not destroyed by Hollywood. She died from a basic deprivation of love in her early life. The movie world gave her the vehicle with which she could communicate. She reached out to the masses for that love.

She was fragile, vulnerable—in desperate need—and willing to do almost anything to fulfill that need. Like a moth's attraction to a flame, she was addicted obsessively to reaching out for love. More even than the rest of us, she needed it to survive.

She exposed a humanness with which we all identified. We were touched by some deep pain and deep beauty in her. Sex was only her vehicle, her contact was far deeper. Both men and women loved her—she affected both equally. It is strange that of all my works, this is the most androgynous. I remember specifically purchasing the Timex watch—I had many others in my prop cabinet, but they all seemed too feminine. The candle holder, though glittering, is smooth and plain—unfrilled. The rhinestone-studded compact is Art Deco and reads more designed and hard than soft and pretty.

I chose a photograph of Marilyn that shows her character in transition. Her face retains qualities of Norma Jean and has not yet fully become Marilyn Monroe. Her hair is still soft —it curled and flowed along with my air brush. In future the blond hair would become brittle, brassy, yellow. That would break and would have had to be painted in a totally different way. The mouth is beginning to look like plastic but has not yet firmly set, although the lips are beginning to crack. The eyes retain a touch of softness and innocence. So far only a trace of pain has lined her brow.

I took more liberties with the reflected distortions in the mirror on the left.

Like an icon she sits, the tools of her trade surrounding her. The rouge jars and powder puff form a crown around her head. I had to have a peach—they were out of season when we were shooting, and Jeanne and I opened many to find the right and beautifully formed erotic pit. The orange is beginning to shrivel . . . decay is setting in . . . the sand is slowly trickling down inside the pink plastic hourglass. In our first shooting I used a white rose, but later changed it for this very specific coral pink one, open and delicate,

80. The artist at work on MARILYN

84

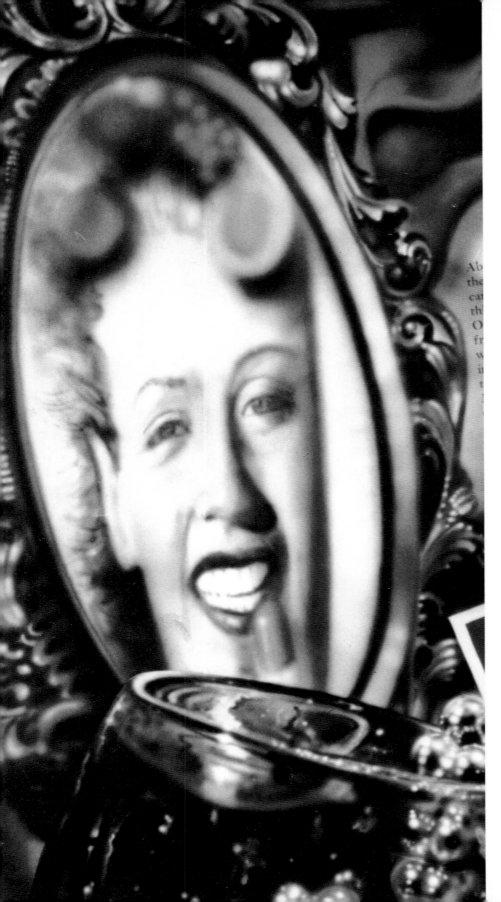

perched precariously over the book and very intentionally placed beside a deep violet satin sheet. Violet is a healing color. That particular pink suggests softness and love.

Marilyn painted herself into an "instrument of her will," using lipsticks, powder puffs, rouge, perfumes. I have used oils, acrylics, canvas, brushes. Each of us has found a way.

Marilyn succeeded—she got her message across. I see her as an iconic figure. She is a Universal Archetype.

About four or five months after she moved into the orphanage, she fell into a depressed mood. It came on during a rainy day. Rain always made her think of her father and set up a desire to wander. On the way back from school, she slipped away from the line and fled. She didn't know where she was running to and wandered aimlessly in the slashing rainstorm. A policeman found her and took her to a police station. She was brought back to Mrs. Dewey's office. She was changed into dry clothes. She expected to be beaten. Instead, Mrs. Dewey took her in her arms and told her she was pretty. Then she powdered Norma Jean's nose and chin with a powder puff.

In 1950, Marilyn told the story of the powder puff to Sonia Wolfson, a publicity woman at 20th Century-Fox and then confided, "This was the first time in my life I felt loved—no one had ever noticed my face or hair or me before."

Let us assume it even happened in some fashion. For it gives a glimpse as the powder goes on and the mirror comes up of a future artist conceiving a grand scheme in the illumination of an instant—one could paint oneself into an instrument of one's will! ". . . Noticed my face or hair"—her properties—"or me . . ."

—From Maurice Zolotow's *Marilyn Monroe* in Norman Mailer, *Marilyn*

81. MARILYN (detail)

82. MARILYN (VANITAS). 1977. Oil over acrylic on canvas, 96 × 96″. Collection the artist

About four or five months after she moved into the orphanage, she fell into a depressed mood. It came on during a rainy day. Rain always made her think of her father and set up a desire to wander. On the way back from school, she slipped away from the line and fled. She didn't know where she was running to and wandered aimlessly in the slashing rainstorm. A policeman found her and took her to a police station. She was brought back to Mrs. Dewey's office. She was changed into dry clothes. She expected to be beaten. Instead, Mrs. Dewey took her in her arms and told her she was pretty. Then she powdered Norma Jean's nose and chin with a powder puff.

In 1956, Marilyn told the story of the powder puff to Sonia Wolfson, a publicity woman at 20th Century-Fox and then confided, "This was the first time in my life I felt loved—no one had ever noticed my face or hair or me before."

Let us assume it even happened in some fashion. For it gives a glimpse as the powder goes on and the mirror comes up of a future artist conceiving a grand scheme in the illumination of an instant—one could paint oneself into an instrument of one's will! ". . . Noticed my face or hair"—her properties—"or me . . ."

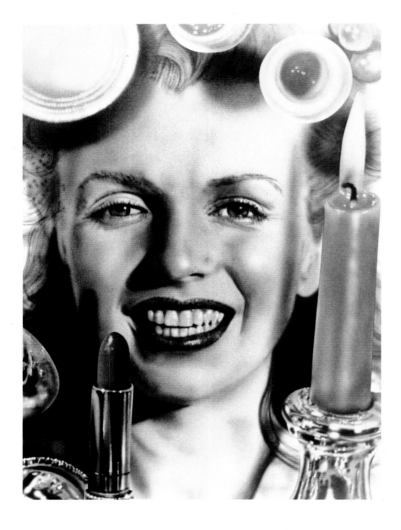

83. MARILYN (detail)

84. Photograph of Marilyn Monroe
 by André de Dienes,
 which, as it appeared
 in Norman Mailer's
 book *Marilyn,* the artist
 used for her photograph of
 the MARILYN still life

85. The artist with MARILYN

Wheel of Fortune

It is hard to tell where the Wheel of Fortune will stop in our lives. This is perhaps the most personal of all of the *Vanitas* paintings. It deals with various aspects of my life . . . the personal tragedy of my autistic daughter Melissa framed in the upper left corner of the painting. It is also why I write the least about this painting.

The poem "Invictus" held great meaning for me from childhood on. I memorized it in my early teens and used it as a source of strength to carry me through some difficult days. "My head is bloody, but unbowed" . . . lipstick . . . skull . . . claret wine. The skull is reflected in the Baroque mirror on the left, as is the small hand mirror. But the reflected image of the hand mirror momentarily exposes a rainbow, signifying the beyond, the afterlife. I am reflected with tripod in the silver crystal-gazing ball, upper right along with some acid grapes and flash spots of light.

I was insistent about the color of those grapes, though it was difficult to achieve the strange orange shade I wanted. A year later in the National Gallery in Washington, while viewing an Edvard Munch exhibition, I stopped sharply in front of a painting which held that *exact* color. The picture was called *The Smell of Death*. Munch had sought the same shade, and for the same associative powers.

In the painting a duality exists between the Wheel of Fortune that casts one's fate and "I am the master of my fate, I am the captain of my soul." Life is a mixture of the two.

I wanted to create a Renaissance mood. A friend borrowed a skull for me, and I enlarged the worm holes. It took a while to locate the correct hourglass, which I had to rent at a high price, for the shooting. I now have a collection of hourglasses. I wanted to evoke the atmosphere of Faust's study . . . tampering with one's fate . . . dealing with it . . . overcoming it.

All of the *Vanitas* paintings are a protest. *Wheel of Fortune* may be the strongest in those terms. They are saying: "Resist! Fight back!" We are subject to Fate, and like Job we are afflicted with pain. But we do have some degree of control over our lives . . . over our fate . . . however slight. Paint yourself into an "instrument of your will."

Do not go gentle into that good night.
Rage, rage against the dying of the light.

Dylan Thomas

86. WHEEL OF FORTUNE (detail)

87. WHEEL OF FORTUNE (VANITAS). 1977–78.
 Oil over acrylic on canvas, 96 × 96".
 HHK Foundation for Contemporary Art, Inc.,
 Milwaukee, Wis.

Invictus

Out of the night that covers me,
 Black as the Pit from pole to pole,
I thank whatever gods may be
 For my unconquerable soul.

In the fell clutch of circumstance
 I have not winced nor cried aloud.
Under the bludgeonings of chance
 My head is bloody, but unbowed.

Beyond this place of wrath and tears
 Looms but the horror of the shade,
And yet the menace of the years
 Finds, and shall find me, unafraid.

It matters not how strait the gate,
 How charged with punishments the scroll,
I am the master of my fate:
 I am the captain of my soul.

 William Ernest Henley

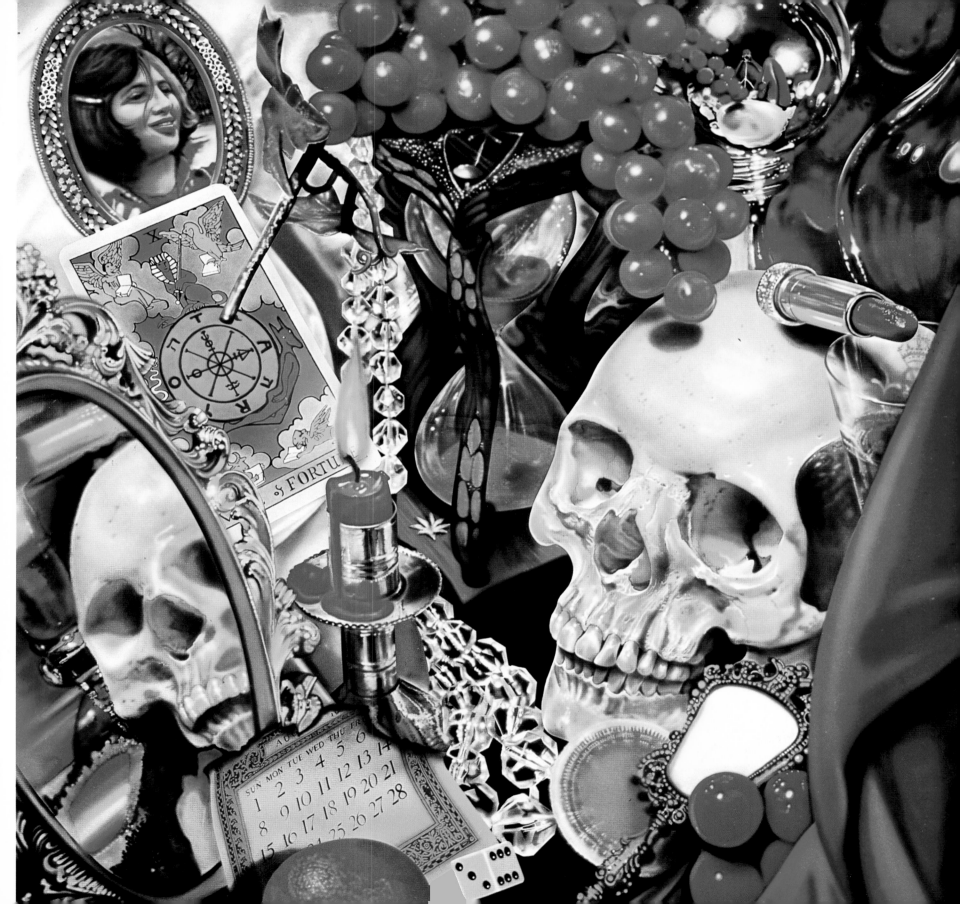

Time to Save

Time to Save is a *Vanitas* flower painting.

The title comes from a clock in the painting which is not just a clock but a bank as well. I suspect it was a gift from a savings bank given for opening an account. I was intrigued with its multiple meanings and immediately purchased it from its flea market stand and added it to my prop collection.

The bank suggests that it is "time to save," meaning money. My interpretation of the *Vanitas* irony is: "Does anyone have 'time to save?' Can anyone save time?" Life is short, time is fleeting.

Resting on the clock, at a precarious angle, is an hourglass, an age-old symbol of the passing of time . . . the sands of time. The skull at bottom left is an overt symbol of the presence of death. It is a miniature porcelain skull and does not dominate the painting as does the human skull in *Wheel of Fortune*. It is at rest.

The painting is of a positive nature. I think of it as a religious painting. A Resurrection or Ascension.

The flower arrangement comes to a peak at the center top of the canvas, where a winged butterfly, a symbol of the liberation of the soul, is about to ascend. A porcelain bird is perched on a crystal compote dish filled with fruits. The bird is an ancient symbol of the soul and was used in both Egyptian and Christian iconography.

Insects, seashells, assorted fruits and flowers all combine with each other, contributing their symbolic power toward sending a message to the viewer. I use a mixture of both classical and "vulgar," artificial and real objects in order to encompass a broad scale of society and life.

88. TIME TO SAVE. 1979.
Oil over acrylic on canvas, 80 × 64″.
Collection the artist

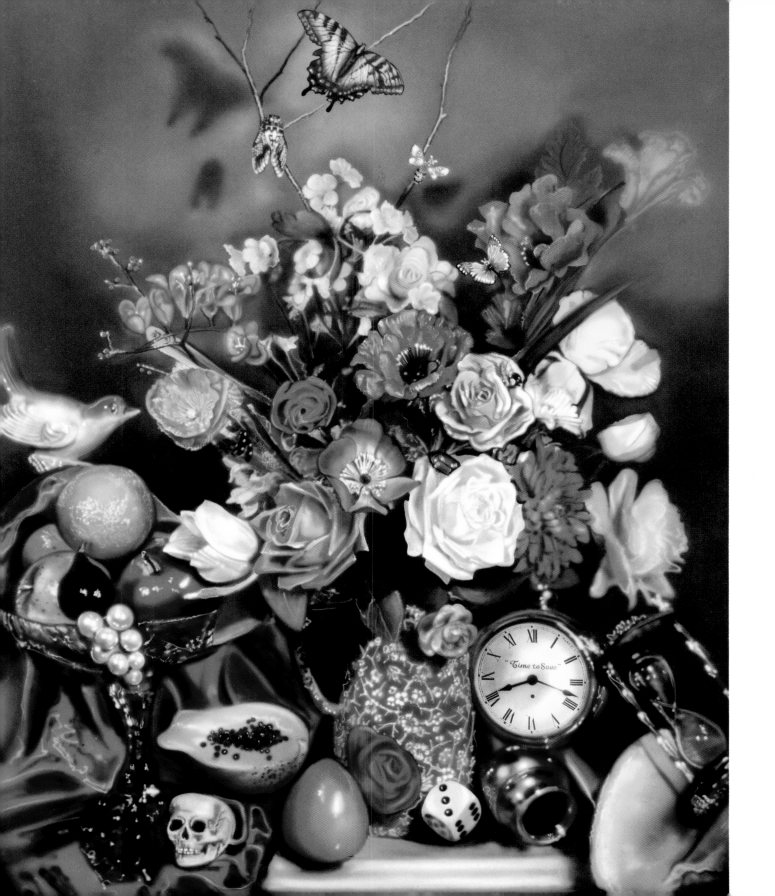

Drawing with the Camera

by Jeanne Hamilton

89–97. Nine steps in arranging TIME TO SAVE
for photography. The cast of characters,
as seen in plate 91, are Jerome Stiller,
friend and collector, the artist, and
Jeanne Hamilton. Stiller is holding
Audrey Flack's poodle, Angelica Kauffman

It all started several years ago when Audrey and I were near neighbors on the Upper West Side. We knew each other only slightly, but I knew she painted and she knew I was a photographer. One day she asked me to help her light a still life she had arranged on her studio table. That was the setup that became *Jolie Madame*, the first in a series of remarkable still-life paintings, and so I became, for whenever she needed me, photographic assistant to Audrey Flack.

I shopped for the Mylar backdrop used in *Spitfire* (and in many photographs afterward), and that trip to the store was the beginning of a delightful, endless treasure hunt for photogenic props—a silver bowl of the right height, a vase of a certain shade of blue, the perfect pear.

When Audrey has clearly in mind what she wants to paint and has accumulated most of the objects, she sets a date for the photographic session. I take some extra flood lamps along to her studio, some extension cords, some afterthought props, and maybe some things of my own that might fit into the picture. Audrey has usually begun to put the objects into place when I arrive.

Every stage of the photographic sessions is easier with four hands than with two, especially when the arrangements are precarious, as they often are. Part of the problem is that Audrey does not, no matter what anyone says, believe in gravity. She wants to paint the objects as if they are flying off the canvas (because we live in the space age, I think), and therefore the objects we photograph have to be one in front of the other—in space, not on the table. We have flown not only toy airplanes, but bunches of grapes, pairs of dice, hourglasses, and anything else that needs to be out there in front—using strings hung from clothes racks or from the ceiling, common pins stuck into pieces of fruit, and chunks of plasticene. In the earliest paintings the objects rested on a tabletop or a curved backdrop, but later Audrey wanted to tilt the picture plane and raise the composition's center higher off the base. This meant building the arrangement up as well as out, and until we learned to build a superstructure first, it also meant supporting the elements with bottles and boxes and plastic blocks, and holding it all together with the ever-useful plasticene and plenty of will power.

A vexing problem we have dealt with more than once is the difference between the way we see a setup and the way the

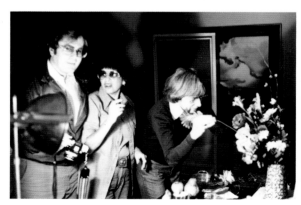

camera sees it. When we shot *Royal Flush* the first time, Audrey arranged it as a poker hand would look on a green felt cloth, but when the film came back she saw that the placement in real life was much too spread out, and did not convey the drama of a poker game. We shot it again and, with each frame, pushed the objects closer and closer together until they impinged on each other and made a composition.

The same thing happened with *Gambler's Cabinet*. It looked as if the cabinet was tightly packed, but the film showed that there was too much space around the objects. And again with *Marilyn*. On the first shooting we used too small a picture of Ms. Monroe. The resulting shot lacked presence and we had to try again, using a larger picture that dominated the other objects. The image of Marilyn Monroe in this second version suggested an icon, as Audrey had conceived it should.

The setups that required the fastest footwork were *Banana Split Sundae, Strawberry Tart*, and the other meltables in that series. We shot them on the kitchen table, whipping the whipped cream into the freezer between shots.

Once we get these balancing acts into the air, making the exposures may be either comparatively easy, as it was with *Solitaire* and *Grand Rosé*, or unexpectedly complicated. The first requirement is to get the maximum light overall. Audrey likes the brightest light possible because she wants brilliance in the paintings, and because she wants sharp slides to paint from. What we usually start with is a main light up quite close, one or maybe two fill lights, and accent lights for whatever special areas need extra light. Sometimes it seems as if we have to do two or three pictures in one. *Buddha*, for instance, had to have a great deal of light. Besides the main light we used two fill lights, lower than usual, directly in front, to shine through the red vase and the blue jar to make them glow, and a lamp from the side for additional highlights.

Both highlights and shadows help to separate objects one from another and to strengthen and deepen the images, but they have to be gently coaxed to fall in the right places and with the right intensity. We also work for two kinds of reflection: the double image that a reflecting surface like Mylar or a shiny tabletop gives back, and the lovely bonus that a well-placed mirror can yield. It took endless tinkering

to get Marilyn Monroe's face repeated in the tilted mirror, and the cherub image twice in *Leonardo's Lady*, but the effect in both cases was worth the trouble.

The trick, of course, is to light each still life for all these values at once. No wonder then that placing and lighting the objects takes the greater part of the day in most sessions.

At this point we load the cameras, the Nikon with Kodachrome type-A or Ektachrome type-B film, and the Hasselblad with Ektachrome. Audrey started the still-life series with a Nikon but changed to a Hasselblad in order to have a larger slide to project. At first its square shape was unfamiliar and disconcerting. It took practice to build the compositions high enough for the square format. We even tried using the Hasselblad as if its film were rectangular, but the space in the viewfinder cried to be filled, and after a while Audrey began to "see square."

At last we come to the shooting. Audrey's favorite lens for the Nikon is the 105mm, and its counterpart the 150mm for the Hasselblad. These lenses allow a close shot with little distortion. I usually take the light readings, and stand ready to adjust props or lights as Audrey makes the exposures. Because a usable slide has to be exposed perfectly, we bracket every shot, a wasteful procedure in one sense but only prudent considering what would be involved in beginning all over again.

Audrey first focuses on an object about one-third of the way back in the setup, using a rule we learned somewhere long ago. (Things in front and in back of that point will be in reasonably good focus too.) Then she may ignore the rule and focus on another area of particular interest. In *World War II*, for instance, the writing in the book had to be clear if Audrey was ever to paint those little tiny words. That had to be the sharpest point in the photograph. There were a few times when it was desirable to throw some part of the picture slightly out of focus, and then we opened up the camera from our customary f/22 or 32 setting to f/8 or 11. Usually, though, we tried for the maximum depth of field. The speeds used were in the 1-second to 1/30-second range most often.

Many of the slides that came out of successful sessions have not yet been shown as photographs. Only recently have a number of them been printed. There are several reasons.

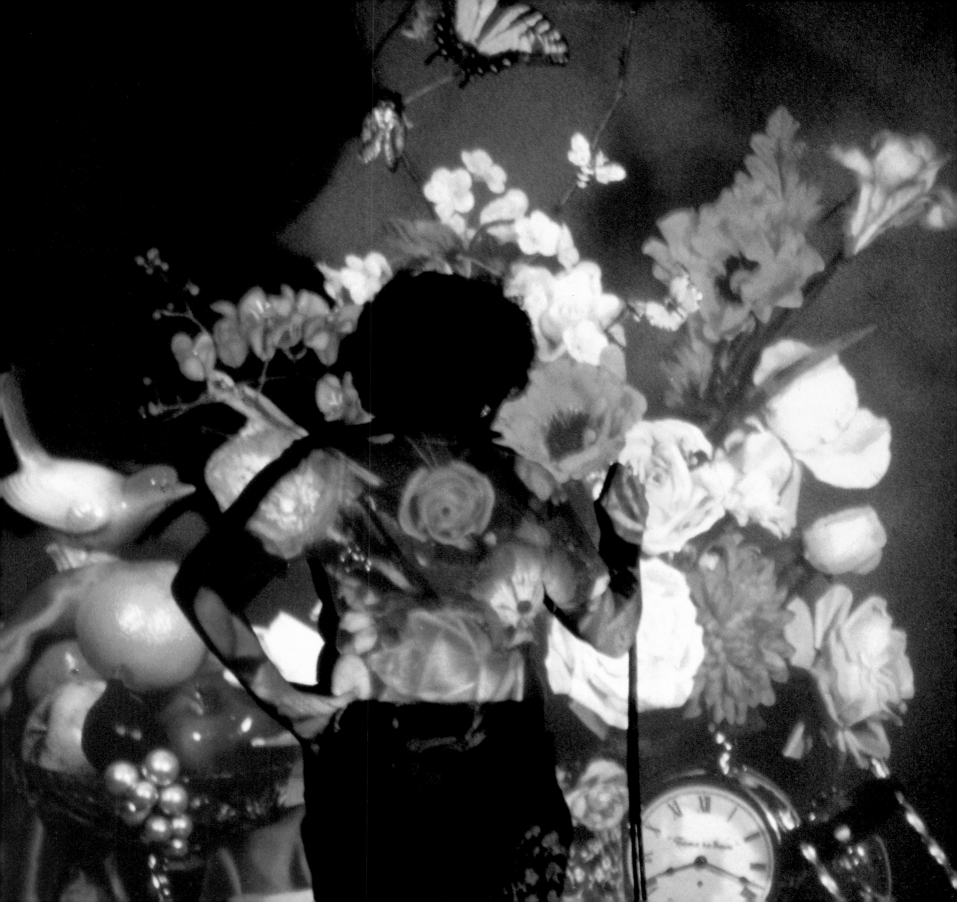

Some of the slides were literally used up in the projector as Audrey painted from them. Some had strings showing (remember those flying grapes?) or plastic boxes sticking out from under the drapery. But the principal reason is that they were the means to the paintings rather than photographs for themselves. The slides were Audrey's drawings. She photographs from the still life, instead of drawing, in order to get totally accurate relationships among the objects, and therefore everything has to be in place before the shutter clicks. That was why we spent so much time on the angle of a butterfly's wing or the slant of a (burning!) candle. Colors are often changed, intensified or subdued, but for the most part the composition is arrived at in the camera. Lately Audrey has done her own color printing (film goes to the lab for developing, but prints can be made in the studio), and she finds that some of the slides that never would work for paintings turn out to be good photographs.

I go on haunting thrift shops and flea markets. I might find a cut-glass compote dish, a flute, or a flag, or a mandolin. I look in every flower shop I pass and into the more promising fruit and vegetable stands. Audrey has been talking about lobsters lately. There may be a seafood special in our futures.

99. The artist at work on TIME TO SAVE

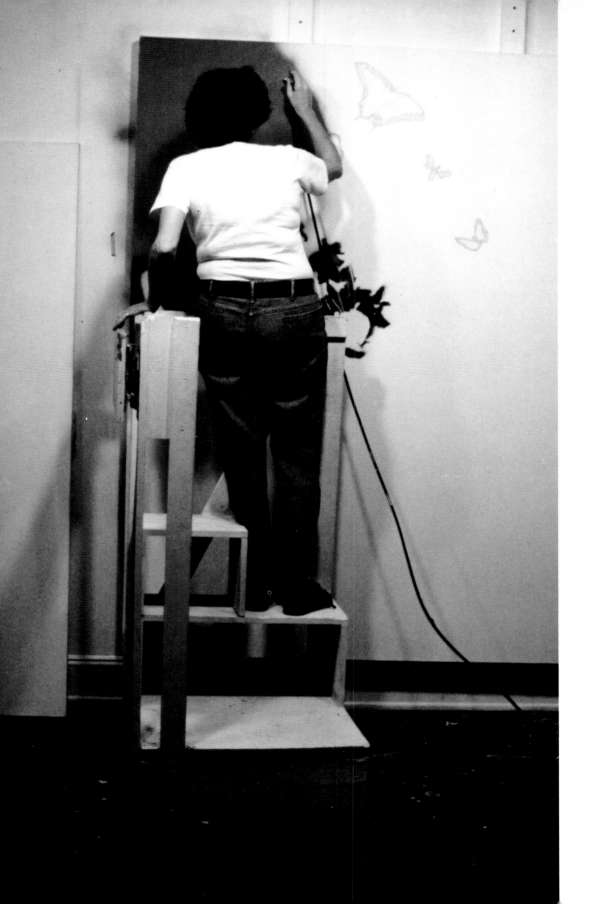

100–101. Time to Save (detail, in progress)

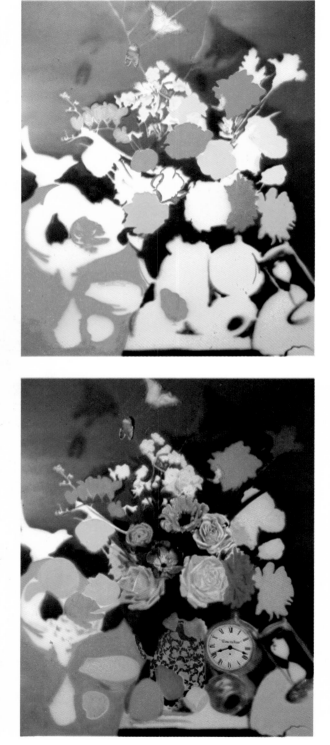

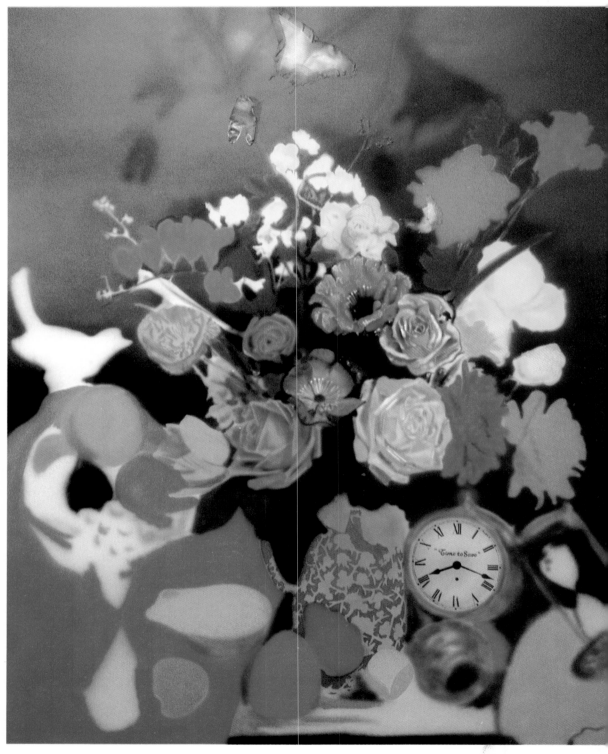

102–107. TIME TO SAVE (in progress)

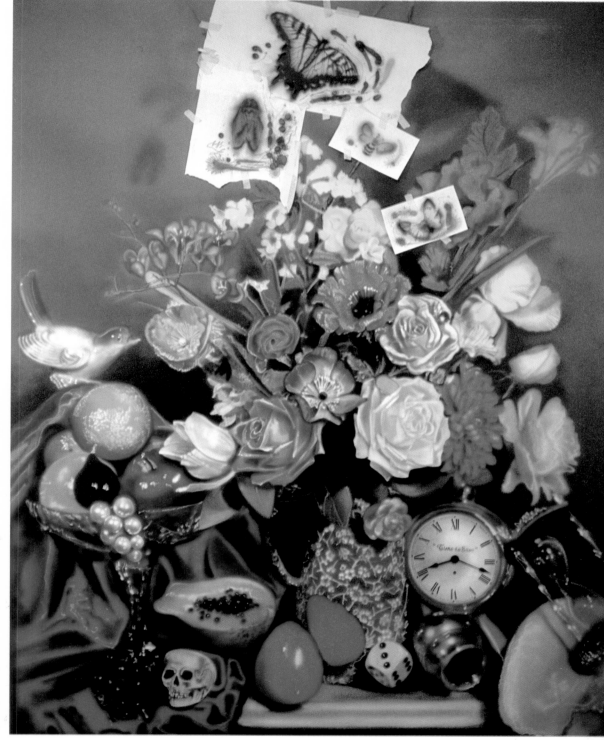

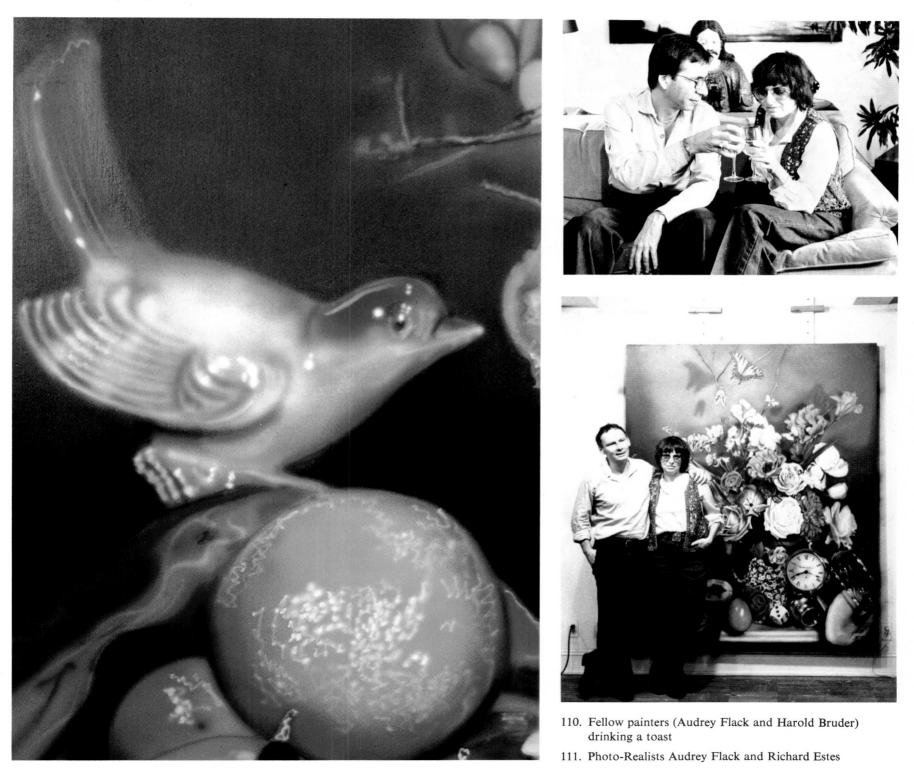

109. TIME TO SAVE (detail)

110. Fellow painters (Audrey Flack and Harold Bruder) drinking a toast

111. Photo-Realists Audrey Flack and Richard Estes

Biography

1931　Born: New York

EDUCATION
1951　Graduated from Cooper Union, New York
1952　B.F.A., Yale University, New Haven, Conn.
1953　New York University, Institute of Fine Arts
1977　Cooper Union Honorary Doctorate

TEACHING
1960–68　Pratt Institute, New York
　　　　New York University, New York
1966–67　Riverside Museum Master Institute, New York
1970–74　School of Visual Arts, New York
　　1975　Albert Dorne Professorship, University of Bridgeport,
　　　　　Conn.

SOLO EXHIBITIONS
1959　Roko Gallery, New York
1963　Roko Gallery, New York
1972　French and Co., New York
1974　Louis K. Meisel Gallery, New York
　　　Joseloff Gallery, University of Hartford, Conn.
1975　Carlson Gallery, Arnold Bernhard Arts Center,
　　　　University of Bridgeport, Conn.
1976　Louis K. Meisel Gallery, New York
1978　Louis K. Meisel Gallery, New York

SELECTED GROUP EXHIBITIONS
1948　"Seventh Annual Exhibition," National Academy of
　　　　Design, New York
1952　Yale University Art Gallery, New Haven, Conn.
1954–57　Tanager Gallery, New York
1956　Collectors Gallery, New York
1960　"Christmas Show," Karnig Gallery, New York
　　　Stable Gallery Annual, New York
1963　Boston University Gallery of Fine Arts
1963–64　"Nine Realist Painters," Robert Schoelkopf Gallery,
　　　　New York
1964　"Ten West Side Artists," Riverside Museum, New York
1965　"Sixty-five Self-Portraits," School of Visual Arts,
　　　　New York
　　　"Six Women," Fischbach Gallery, New York
1967　Goddard-Riverside Community Center, New York
1969　"Paintings from the Photograph," Riverside Museum,
　　　　New York
1970　"New Realism, 1970," Headley Hall Gallery, St. Cloud
　　　　State College, Minn.
　　　"Twenty-two Realists," Whitney Museum of American
　　　　Art, New York
1972　"Annual Exhibit of Contemporary American
　　　　Paintings," Whitney Museum of American Art,
　　　　New York

"Artists for CORE," Grippi and Waddell Gallery, New York

Clark Polak Gallery, Los Angeles

"L'Hyperréalistes américains," Galerie des Quatre Mouvements, Paris

"New Accessions U.S.A.," Colorado Springs Fine Arts Center, Col.

"Painting and Sculpture Today, 1972," Indianapolis Museum of Art

"Phases of the New Realism," Lowe Art Museum, University of Miami, Coral Gables, Fla.

"Realism Now," New York Cultural Center, New York

"Thirty-two Realists," Cleveland Institute of Art

Warren Benedek Gallery, New York

"Women in Art," Brainerd Hall Art Gallery, State University College, Potsdam, N.Y.

1973 "American Drawings 1963–1973," Whitney Museum of American Art, New York

"Amerikansk realism," Galleri Ostergren, Malmö, Sweden

"The Emerging Real," Storm King Art Center, Mountainville, N.Y.

"Hyperréalistes américains," Galerie Arditti, Paris

"Objects and Eight Women Realists," University of Massachusetts, Amherst, Mass.

"Photo-Realism," Serpentine Gallery, London

"Realism Now," Katonah Gallery, Katonah, N.Y.

"The Super-Realist Vision," DeCordova and Dana Museum, Lincoln, Mass.

"Women Choose Women," New York Cultural Center, New York

1973–78 "Photo-Realism 1973: The Stuart M. Speiser Collection," traveling exhibition: Louis K. Meisel Gallery, New York; Herbert F. Johnson Museum of Art, Ithaca, N.Y.; Memorial Art Gallery of the University of Rochester, N.Y.; Addison Gallery of American Art, Andover, Mass.; Allentown Art Museum, Pa.; University of Colorado Museum, Boulder; University Art Museum, University of Texas, Austin; Witte Memorial Museum, San Antonio, Tex.; Gibbes Art Gallery, Charleston, S.C.; Brooks Memorial Art Gallery, Memphis, Tenn.; Krannert Art Museum, University of Illinois, Champaign-Urbana; Helen Foresman Spencer Museum of Art, University of Kansas, Lawrence; Paine Art Center and Arboretum, Oshkosh, Wis.; Edwin A. Ulrich Museum, Wichita State University, Kan.; Tampa Bay Art Center, Tampa, Fla.; Rice University, Sewall Art Gallery, Houston; Tulane University Art Gallery, New Orleans; Smithsonian Institution, Washington, D.C.

1974 "Amerikaans fotorealisme grafiek," Hedendaagse Kunst, Utrecht; Palais des Beaux-Arts, Brussels

"Ars '74 Ateneum," Fine Arts Academy of Finland, Helsinki

"Art 5 '74," Basel, Switzerland

"Contemporary American Painting and Sculpture, 1974," Krannert Art Museum, University of Illinois, Champaign-Urbana

"Contemporary Portraits by American Painters," Lowe Art Museum, University of Miami, Coral Gables, Fla.

"From Teapot Dome to Watergate," Everson Museum of Art, Syracuse, N.Y.

Moos Gallery, Montreal

Moos Gallery, Toronto

"New Image in Painting," Tokyo International Biennale

"New Photo-Realism," Wadsworth Atheneum, Hartford, Conn.

"New Realism Revisited," Brainerd Hall Art Gallery, State University College, Potsdam, N.Y.

"New York Eleven," C.W. Post Art Gallery, Greenvale, N.Y.

"Thirty-eighth Annual Midyear Show," Butler Institute of American Art, Youngstown, Ohio

"Tokyo Biennale, '74," Tokyo Metropolitan Museum of Art; Kyoto Municipal Museum; Aichi Prefectural Art Museum, Nagoya

"Women's Work: American Art 1974," Museum of the Philadelphia Civic Center

1975 "Art: A Woman's Sensibility," California Institute of the Arts, Valencia, Cal.

"Image, Color and Form—Recent Paintings by Eleven Americans," Toledo Museum of Art, Ohio

Kent Bicentennial Portfolio: "Spirit of Independence," exhibited in 105 museums, 50 states

"The New Realism: Rip-Off or Reality?" Edwin A. Ulrich Museum, Wichita State University, Kan.

"Photo-Realists," Louis K. Meisel Gallery, New York

"Report from SoHo," New York University, Grey Art Gallery, New York

"Watercolors and Drawings—American Realists," Louis K. Meisel Gallery, New York

"The Year of the Woman," Bronx Museum of the Arts, New York

1975–76 "Photo-Realism, American Painting and Prints," New Zealand traveling exhibition: Barrington Gallery, Auckland; Robert McDougall Art Gallery, Christchurch; Academy of Fine Arts, National Art Gallery, Wellington; Dunedin Public Art Gallery, Dunedin; Govett-Brewster Art Gallery, New Plymouth; Waikato Art Museum, Hamilton

"Super Realism," Baltimore Museum of Art

1976 "American Artists '76: A Celebration," Marion Koogler
McNay Art Institute, San Antonio, Tex.
"Artists and East Hampton," Guild Hall Art Gallery,
East Hampton, N.Y.
"Art 7 '76," Basel, Switzerland
Lowe Art Museum, University of Miami, Coral
Gables, Fla.
Roko Gallery, New York
"Troisième foire internationale d'art contemporain,"
Grand Palais, Paris
Young Hoffman Gallery, Chicago
1976–77 "The Aubrey Cartwright Foundation Exhibition of
Contemporary Religious Art," Cathedral Church of
St. John the Divine, New York
1976–78 "Aspects of Realism," traveling exhibition sponsored
by Rothman's of Pall Mall Canada, Ltd.: Stratford,
Ont.; Centennial Museum, Vancouver, B.C.;
Glenbow-Alberta Institute, Calgary, Alta.; Mendel
Art Gallery, Saskatoon, Sask.; Winnipeg Art
Gallery, Man.; Edmonton Art Gallery, Alta.; Art
Gallery, Memorial University of Newfoundland, St.
John's; Confederation Art Gallery and Museum,
Charlottetown, P.E.I.; Musée d'Art Contemporain,
Montreal, Que.; Dalhousie University Museum and
Gallery, Halifax, N.S.; Windsor Art Gallery, Ont.;
London Public Library and Museum and McIntosh
Memorial Art Gallery, University of Western
Ontario; Art Gallery of Hamilton, Ont.
1977 "Alumni Exhibition," Houghton Gallery, Cooper
Union for the Advancement of Science and Art,
New York
"Breaking the Picture Plane," Tomasulo Gallery,
Union College, Cranford, N.J.
"The Chosen Object: European and American Still
Life," Joslyn Art Museum, Omaha
"New in the '70s," University Art Museum, Archer M.
Huntington Gallery, University of Texas, Austin
"New Realism," Jacksonville Art Museum, Fla.
"Photo-Realists," Shore Gallery, Boston
"Washington International Art Fair," Washington,
D.C.
Woman's Caucus for Art, New York
"Works on Paper II," Louis K. Meisel Gallery, New
York
1977–78 "Illusion and Reality," Australian touring exhibition:
Australian National Gallery, Canberra; Western
Australian Art Gallery, Perth; Queensland Art
Gallery, Brisbane; Art Gallery of New South Wales,
Sydney; Art Gallery of South Australia, Adelaide;
National Gallery of Victoria, Melbourne;
Tasmanian Museum and Art Gallery, Hobart

"June Blum, Audrey Flack, Alice Neel: Three
Contemporary American Women Realists," Miami-
Dade Community College, South Campus Art
Gallery, Miami, Fla.
1978 "Art About Art," Whitney Museum of American Art,
New York; North Carolina Museum of Art,
Raleigh; Frederick S. Wight Art Gallery, University
of California, Los Angeles; Portland Art Museum,
Ore.
"Artists Look at Art," Helen Foresman Spencer
Museum of Art, University of Kansas, Lawrence
"Aspects of Realism," Guild Hall Art Gallery, East
Hampton, N.Y.
Brookdale Community College, N.J.
"Drawing the Line," Montclair Art Museum,
Montclair, N.J.
Monmouth Museum, Lincroft, N.J.
"Perspective '78: Works by Women," Freedman Art
Gallery, Albright College, Reading, Pa.
"Photo-Realism and Abstract Illusionism," Arts and
Crafts Center of Pittsburgh, Pa.
"Photo-Realist Printmaking," Louis K. Meisel Gallery,
New York
Tolarno Galleries, Melbourne, Australia
"Washington International Art Fair," Washington, D.C.
Woman's Interart Center, New York
1978–80 "American Painting of the 70s," Albright-Knox Art
Gallery, Buffalo; Newport Harbor Art Museum,
Balboa, Calif.; Oakland Museum, Cal.; Cincinnati
Art Museum; Art Museum of South Texas, Corpus
Christi; Krannert Art Museum, University of
Illinois, Champaign-Urbana
1979 "Narrative Realism," Art Association of Newport, R.I.
"The New American Still Life," Westmoreland County
Museum of Art, Greensburg, Pa.
"The Opposite Sex: A Realistic Viewpoint," University
of Missouri Art Gallery, Kansas City
"Photo-Realism: Some Points of View," Jorgensen
Gallery, University of Connecticut, Storrs
"Realist Space," C.W. Post Art Gallery, Long Island
University, Brookville, N.Y.
"Selections of Photo-Realist Paintings from N.Y.C.
Galleries," Southern Alleghenies Museum of Art,
St. Francis College, Loretto, Pa.
Vision Gallery, Boston
Washington International Art Fair, Washington, D.C.
"Women Artists of Eastern Long Island," Guild Hall,
East Hampton, N.Y.
1979–80 "Genesis of a Gallery, Part 2," Australian National
Gallery, Canberra, to travel throughout Australia.
The Vice President's House, Washington, D.C.

Selected Bibliography

CATALOGUES

Nine Realist Painters. Robert Schoelkopf Gallery, New York, Dec. 19, 1963–Jan. 4, 1964.

Farb, Oriole. Introduction to *Paintings from the Photograph.* Riverside Museum, New York, Dec. 9, 1969–Feb. 15, 1970.

Monte, James. Introduction to *Twenty-two Realists.* Whitney Museum of American Art, New York, Feb. 1970.

Wallin, Lee. Introduction to *New Realism, 1970.* St. Cloud State College, Minn., Feb. 13–Mar. 11, 1970.

Baratte, John J., and Thompson, Paul E. *Phases of the New Realism.* Lowe Art Museum, University of Miami, Coral Gables, Fla., Jan. 20–Feb. 20, 1972.

Baur, John H. Foreword to *1972 Annual Exhibit of Contemporary American Paintings.* Whitney Museum of American Art, New York, Jan. 25–Mar. 19, 1972.

Goldsmith, Benedict. Introduction to *Women in Art.* Brainerd Hall Art Gallery, State University College, Potsdam, N.Y., Mar. 3–28, 1972.

Naeve, Milo M. Introduction to *New Accessions U.S.A.* Colorado Springs Fine Arts Center, Colo., Aug. 14–Oct. 1, 1972.

Warrum, Richard L. Introduction to *Painting and Sculpture Today, 1972.* Indianapolis Museum of Art, Apr. 26–June 4, 1972.

Amaya, Mario. Introduction to *Realism Now.* New York Cultural Center, New York, Dec. 6, 1972–Jan. 7, 1973.

Alloway, Lawrence. Introduction to *Amerikansk Realism.* Galleri Ostergren, Malmö, Sweden, Sept. 8–Oct. 14, 1973.

———. Introduction to *Photo-Realism.* Serpentine Gallery, London, Apr. 4–May 6, 1973.

Hogan, Carroll Edwards. Introduction to *Hyperréalistes américains.* Galerie Arditti, Paris, Oct. 16–Nov. 30, 1973.

Lamagna, Carlo. Foreword to *The Super-Realist Vision.* DeCordova and Dana Museum, Lincoln, Mass., Oct. 7–Dec. 9, 1973.

Lippard, Lucy. Introduction to *Women Choose Women.* Preface by Mario Amaya. New York Cultural Center, New York, Jan. 12–Feb. 18, 1973.

Meisel, Louis K. *Photo-Realism 1973: The Stuart M. Speiser Collection.* New York, 1973.

Mochon, Anne, and Levin, Miriam. Introduction to *Objects and Eight Women Realists.* University of Massachusetts, Amherst, Mass., Nov. 18–Dec. 14, 1973.

Sims, Patterson. Introduction to *Realism Now.* Katonah Gallery, Katonah, N.Y., May 20–June 24, 1973.

Solomon, Elke M. *American Drawings 1963–1973.* Whitney Museum of American Art, New York, 1973.

Alloway, Lawrence. Introduction to *New York Eleven.* Foreword by Joan Vita Miller. C. W. Post College, Greenvale, New York, Feb. 8–Mar. 11, 1974.

Amerikaans fotorealisme grafiek. Hedendaagse Kunst, Utrecht,

Aug., 1974; Palais des Beaux-Arts, Brussels, Sept.–Oct., 1974.

Aspects of Realism. Gallery Moos Ltd., Toronto, Sept.–Oct., 1974.

Campbell, Alan. Introduction to *From Teapot Dome to Watergate.* Everson Museum of Art, Syracuse, N.Y., May 2–12, 1974.

Chase, Linda. "Photo-Realism." In *Tokyo Biennale 1974.* Tokyo Metropolitan Museum of Art; Kyoto Municipal Museum; Aichi Prefectural Art Museum, Nagoya, 1974.

Cowart, Jack. *New Photo-Realism.* Wadsworth Atheneum, Hartford, Conn., Apr. 10–May 19, 1974.

Goldsmith, Benedict. *New Realism Revisited.* Brainerd Hall Art Gallery, State University College, Potsdam, N.Y., 1974.

Gruen, John. Introduction to *Contemporary Portraits by American Painters.* Lowe Art Museum, University of Miami, Coral Gables, Fla., Oct. 3–Nov. 10, 1974.

Michiaki, Kawakita. Preface to *New Image in Painting.* Tokyo International Biennale, June, 1974.

Perreault, John. "The Present Situation of American Art." In *New Image in Painting.* Tokyo International Biennale, June, 1974.

Sarajas-Korte, Salme. Introduction to *Ars '74 Ateneum.* Fine Arts Academy of Finland, Helsinki, Feb. 15–Mar. 31, 1974.

Thirty-eighth Annual Midyear Show. Butler Institute of American Art, Youngstown, Ohio, June 30–Sept. 2, 1974.

Walthard, Dr. Frederic P. Foreword to *Art 5 '74.* Basel, Switzerland, June 19–24, 1974.

Woman's Work: American Art 1974. Museum of the Philadelphia Civic Center, Pa., Apr. 27–May 26, 1974.

Baur, John H. Introduction to *Kent Bicentennial Portfolio: Spirit of Independence.* Exhibited in 105 museums, 50 states, 1975.

Meisel, Susan Pear. *Watercolors and Drawings—American Realists.* Louis K. Meisel Galley, New York, Jan., 1975.

Metzger, Deena. Introduction to *Art: A Woman's Sensibility.* California Institute of the Arts, Valencia, 1975.

Phillips, Robert F. Introduction to *Image, Color and Form— Recent Paintings by Eleven Americans.* Toledo Museum of Art, Ohio, Jan. 12–Feb. 9, 1975.

Von Baron, Judith. Introduction to *The Year of the Woman.* Bronx Museum of Arts, New York, Jan. 16–Feb. 20, 1975.

Richardson, Brenda. Introduction to *Super Realism.* Baltimore Museum of Art, Nov. 18, 1975–Jan. 11, 1976.

Artists and East Hampton. Guild Hall, East Hampton, N.Y., Aug. 14–Oct. 3, 1976.

Felluss, Elias A. Foreword to *Washington International Art Fair.* Washington, D.C., 1976.

Gervais, Daniel. Introduction to *Troisième foire internationale d'art contemporain.* Grand Palais, Paris, Oct. 16–24, 1976.

Glaser, Bruce. Introduction to *Audrey Flack: The Gray Border Series.* Preface by Louis K. Meisel. Louis K. Meisel Gallery, New York, Apr. 10–May 1, 1976.

Simkins, Alice C. Introduction to *American Artists '76: A Celebration.* Preface by John Palmer Leeper. Marion Koogler McNay Art Institute, San Antonio, Tex., 1976.

Walthard, Dr. Frederic P. Introduction to *Art 7 '76.* Basel, Switzerland, June 16–21, 1976.

Chase, Linda. "U.S.A." In *Aspects of Realism.* Rothman's of Pall Mall Canada, Ltd., June, 1976–Jan., 1978.

Ratcliff, Carter. Introduction to *The Aubrey Cartwright Foundation Exhibition of Contemporary Religious Art.* Cathedral Church of St. John the Divine, New York, Nov. 18, 1976–Jan. 2, 1977.

Cloudman, Ruth H. Introduction to *The Chosen Object: European and American Still Life.* Joslyn Art Museum, Omaha, Apr. 23–June 5, 1977.

Dempsey, Bruce. *New Realism.* Jacksonville Art Museum, Fla., 1977.

Felluss, Elias A. Foreword to *Washington International Art Fair.* Washington, D.C., 1977.

Seabolt, Fred. Introduction to *New in the '70s.* Foreword by Donald Goodall. University Art Museum, Archer M. Huntington Gallery, University of Texas, Austin, Aug. 21– Sept. 25, 1977.

June Blum, Audrey Flack, Alice Neel: Three Contemporary American Women Realists. Miami-Dade Community College, South Campus Art Gallery, Fla., Dec. 5–6, 1977, Jan. 4–19, 1978.

Stringer, John. Introduction to *Illusion and Reality.* Australian Gallery Directors' Council, North Sydney, N.S.W., 1977–78.

Alloway, Lawrence. Introduction to *Audrey Flack: Vanitas.* Louis K. Meisel Gallery, New York, Mar. 23–May 4, 1978.

Hennessey, William. *Artists Look at Art.* Foreword by Charles Eldredge. Helen Foresman Spencer Museum of Art, University of Kansas, Lawrence, Jan. 15–Mar. 12, 1978.

Koenig, Robert J. Introduction to *Drawing the Line.* Foreword by Kathryn E. Gamble. Montclair Art Museum, Montclair, N.J., Jan. 22–Mar. 19, 1978.

Meisel, Susan Pear. Introduction to *The Complete Guide to Photo-Realist Printmaking.* Louis K. Meisel Gallery, New York, Dec., 1978.

Schwartz, Therese. Introduction to *Perspective '78: Works by Women.* Freedman Gallery, Albright College, Reading, Pa., Oct. 8–Nov. 15, 1978.

Young, Mahonri Sharp. Foreword to *Aspects of Realism.* Guild Hall Art Gallery, East Hampton, N.Y., July 22–Aug. 13, 1978.

Cathcart, Linda L. *American Painting of the 70's.* Albright-Knox Art Gallery, Buffalo, Dec. 8, 1978–Jan. 14, 1979; Newport Harbor Art Museum, Balboa, Calif., Feb. 3–Mar. 18, 1979; Oakland Museum, Calif., Apr. 10–May 20, 1979; Cincinnati Art Museum, July 6–Aug. 26, 1979; Art Museum of South Texas, Corpus Christi, Sept. 9–Oct. 21, 1979; Krannert Art Museum, University of Illinois, Champaign-Urbana, Nov.

11, 1979–Jan. 2, 1980.

Chew, Paul A. Introduction to *The New American Still Life.* Westmoreland County Museum of Art, Greensburg, Pa., June 3–July 15, 1979.

Cooper, Marve H. Introduction to *Narrative Realism.* Art Association of Newport, R.I., Aug. 18–Sept. 16, 1979.

Felluss, Elias A. Introduction to *Washington International Art Fair '79.* May 2–7, 1979.

Gerling, Steve. Introduction to *Photo-Realism: Some Points of View.* Jorgensen Gallery, University of Connecticut, Storrs, Mar. 19–Apr. 10, 1979.

Miller, Wayne. Introduction to *Realist Space.* Foreword by Joan Vita Miller. C. W. Post Art Gallery, Long Island University, Brookville, N.Y., Oct. 19–Dec. 14, 1979.

Streuber, Michael. Introduction to *Selections of Photo-Realist Paintings from N.Y.C. Galleries.* Southern Alleghenies Museum of Art, St. Francis College, Loretto, Pa., May 12–July 8, 1979.

Mollison, James. Introduction to *Genesis of a Gallery, Part 2.* Australian National Gallery, Canberra, 1979–80.

Brown, J. Carter. Foreword to *The Morton G. Neumann Family Collection.* Profile by Sam Hunter. National Gallery of Art, Washington, D.C., Aug. 31–Dec. 31, 1980.

Hills, Patricia and Tarbell, Roberta. "The Figurative Tradition and the Whitney Museum of American Art: Paintings and Sculpture from the Permanent Collection," June 25–Sept. 28, 1980.

Perreault, John. *Aspects of the '70s: Directions in Realism.* Danforth Museum, Framingham, Mass., May 17–Aug. 24, 1980.

Spear, Richard. Foreword to *From Rembrandt to Christo.* Allen Memorial Art Museum, Oberlin College, Ohio, 1980.

ARTICLES

Mellow, James R. "Audrey Flack," *Arts Magazine,* Feb., 1959.

Sandler, Irving. "New Names This Month," *ARTnews,* Feb., 1959.

Raynor, Vivien. "Audrey Flack," *Arts Magazine,* Mar., 1963.

Adler, Robert. "West Side Artists: A New Awareness," *West Side News,* Oct. 1, 1964, p. 3.

"Art Tour: The Galleries—A Critical Choice," *New York Herald Tribune,* Mar. 19, 1966.

Alloway, Lawrence. "Art," *The Nation,* Dec. 29, 1969, pp. 741–42.

Baumgold, Julie, ed. "Best Bets," *New York Magazine,* Dec. 8, 1969.

Gaynor, Frank. "Photographic Exhibit Depicts Today's U.S.," *Newark Sunday News,* Dec. 14, 1969, sec. 6, p. E 18.

Perreault, John. "Get the Picture?" *Village Voice,* Dec. 18, 1969.

Nemser, Cindy. "Paintings from the Photograph," *Arts Magazine,* Dec.–Jan., 1969–1970.

Alloway, Lawrence. "In the Museums, Paintings from the Photo," *Arts Magazine,* Dec. 1, 1970.

Coleman, A. D. "Latent Image," *Village Voice,* Jan. 1, 1970.

Deschin, Jacob. "Photo into Painting," *New York Times,* Jan. 4, 1970.

Genauer, Emily. "On the Arts," *Newsday,* Feb. 21, 1970.

Lichtblau, Charlotte. "Painter's Use of Photographs Explored," *Philadelphia Enquirer,* Feb. 1, 1970.

Lord, Barry. "The 11 O'Clock News in Color," *Arts/Canada,* June, 1970, pp. 4, 21.

New York Times, Nov. 8, 1970, sec. II, pp. 6, 25.

Ratcliff, Carter. "Twenty-two Realists Exhibit at the Whitney," *Art International,* Apr., 1970, p. 105.

Stevens, Carol. "Message into Medium: Photography as an Artist's Tool," *Print,* vol. XXIV, no. III (May 6, 1970), pp. 54–59.

Stevens, Elizabeth. "The Camera's Eye on Canvas," *Wall Street Journal,* Jan. 6, 1970.

"Acquisitions by the Museum 1971–1972," *Whitney Review,* 1971–72.

Whitworth, Sarah. "Journeys in Art: Audrey Flack: Three Views," *The Ladder,* Dec., 1971–Jan., 1972, pp. 32–35, cover.

Benedict, Michael. "Audrey Flack," *ARTnews,* Apr., 1972.

Borsick, Helen. "Realism to the Fore," *Cleveland Plain Dealer,* Oct. 8, 1972.

Canaday, John. "Audrey Flack," *New York Times,* Mar. 4, 1972.

Henry, Gerrit. "The Real Thing," *Art International,* Summer, 1972, pp. 87–91.

Karp, Ivan. "Rent Is the Only Reality, or the Hotel Instead of the Hymn," *Arts Magazine,* Dec., 1972, pp. 47–51.

Kirkwood, Marie. "Art Institute's Exhibit Represents the Revolt Against Abstraction," *Sun Press* (Ohio), Oct. 12, 1972.

Naimer, Lucille. "The Whitney Annual," *Arts Magazine,* Mar., 1972, p. 54.

Nemser, Cindy. "Close-Up Vision: Representational Art," *Arts Magazine,* May, 1972, pp. 44–48.

———. "New Realism," *Arts Magazine,* Nov., 1972, p. 85.

Pozzi, Lucio. "Super realisti U.S.A.," *Bolaffiarte,* no. 18 (Mar., 1972), pp. 54–63.

Wasmuth, E. "La révolte des réalistes," *Connaissance des Arts,* June, 1972, pp. 118–23.

Wooten, Dick. "Something New? Real Pictures?" *Cleveland Press,* Oct. 17, 1972, p. 9.

Allen, Barbara. "In and Around," *Interview Magazine,* Nov., 1973, p. 36.

"Amiens Notre Dame," *Kunstforum International,* Mar. 4, 1973, p. 158.

Art Now Gallery Guide, Sept., 1973, pp. 1–3.

Azara, Nancy. "Artists in Their Own Image," *Ms.,* Jan., 1973, p. 57.

Beardsall, Judy. "Stuart M. Speiser Photorealist Collection," *Art Gallery Magazine,* vol. XVII, no. 1 (Oct., 1973), pp. 5, 29–34.

Bell, Jane. "Stuart M. Speiser Collection," *Arts Magazine,* Dec., 1973, p. 57.

Drexler, Rosalyn. "Audrey Flack," *New York Times,* Jan., 1973.

"Goings on About Town," *The New Yorker,* Oct. 1, 1973.

Gold, Barbara. "Sisterhood in New York," *Baltimore Sun,* Feb. 4, 1973.

Guercio, Antonio del. "Iperrealismo tra 'pop' e informale," *Rinascita,* no. 8 (Feb. 23, 1973), p. 34.

Henry, Gerrit. "A Realist Twin Bill," *ARTnews,* Jan., 1973, pp. 26–28.

"L'Hyperréalisme américain," *Le Monde des Grandes Musiques,* no. 2 (Mar.–Apr., 1973), pp. 4, 56–57.

Lubell, Ellen. "Women Choose Women," *Arts Magazine,* Mar.–Apr., 1973.

Mizue (Tokyo), vol. 8, no. 821 (1973).

"Neue Sachlichkeit—Neuer Realismus," *Kunstforum International,* Mar. 4, 1973, pp. 114–19.

Perreault, John. "Airplane Art in a Head Wind," *Village Voice,* Oct. 4, 1973, p. 24.

———. "Winning a Place in the Show," *Village Voice,* Jan. 25, 1973.

"Realism Now," *Patent Trader,* May 26, 1973, p. 7A.

"Reviews and Previews," *ARTnews,* Mar., 1973.

Sheridan, Lee. " 'Women-Women' Contains Spirit," *Springfield Daily News,* Arts section, Feb. 9, 1973, p. 14.

B. M. "Reviews and Previews: Audrey Flack," *ARTnews,* vol. 71, no. 2 (Apr., 1974).

Coleman, A. D. "From Today Painting Is Dead," *Camera 35,* July, 1974, pp. 34, 36–37, 78.

"Collection of Aviation Paintings at Gallery," *Andover* (Mass.) *Townsman,* Feb. 28, 1974.

Forman, Nessa. "Goodbye to the Femme Fatale," *ARTnews,* Summer, 1974, pp. 65–66.

Frackman, Noel. "Audrey Flack," *Arts Magazine,* May, 1974, p. 70.

Frank, Peter. "Audrey Flack," *Soho Weekly News,* Apr. 11, 1974.

"Gallery Notes," *Memorial Art Gallery of the University of Rochester Bulletin,* vol. 39, no. 5 (Jan., 1974).

Goldenthal, Jolene. "Look at Art: Photo-Real Show at Atheneum," *Hartford Courant,* Apr. 14, 1974, p. 12F.

Goldenthal, June. "Look at Art: Audrey Flack, Photorealist," *Hartford Courant,* May 9, 1974.

Henry, Gerrit. "Reviews and Previews," *ARTnews,* May, 1974, pp. 91–92.

Hill, Richard. "The Technologies of Vision," *Art Magazine* (Toronto), vol. 6, no. 19 (Fall, 1974), p. 10.

Hughes, Robert. "An Omnivorous and Literal Dependence," *Arts Magazine,* June, 1974, pp. 25–29.

Kozloff, Max. "Audrey Flack," *Artforum,* June, 1974, p. 65.

"Letter to the Editor," *Soho Weekly News,* Apr. 18, 1974.

Levin, Kim. "Audrey Flack at Meisel," *Art in America,* May–June, 1974, p. 106.

Nemser, Cindy. "Conversations with Audrey Flack," *Arts Magazine,* Feb., 1974, pp. 34–38.

———. "Letter to Audrey Flack Re: Kozloff on Audrey Flack," *Feminist Art Journal,* vol. 3, no. 3 (Fall, 1974).

"New York Eleven," *North Shore Commentary,* Feb. 14, 1974.

Perreault, John. "Glints of Glass, a Whiff of Poetry," *Village Voice,* Apr. 4, 1974.

———. "Reading a Monumental Still Life," *Village Voice,* May 2, 1974, p. 45.

Picard, Lil. "In... Out... und in Again," *Kunstforum International,* Jan. 2, 1974, pp. 215–17.

Progresso fotografico, Dec., 1974, pp. 61–62.

Saradoff, Lucia. "Outraged Women Artists...," *Soho Weekly News,* Jan. 16, 1974, pp. 2, 4, 5, 16.

School of Visual Arts Catalog, Spring, 1974, cover.

Spear, Richard. "Acquisitions 1973–1974," *Allen Memorial Art Museum Bulletin,* vol. XXXIII (Oberlin College), 1974–75, p. 17.

Stubbs, Ann. "Audrey Flack," *Soho Weekly News,* Apr. 4, 1974.

Vlack, Carol. "Photo Realist Audrey Flack Displays Works at MAG," *University of Rochester Campus Times,* Jan. 18, 1974, p. 9.

Walsh, Sally. "Paintings that Look Like Photos," *Rochester Democrat and Chronicle,* Jan. 17, 1974.

Zabel, Joe. "Realistic Works Predominate in 1974 Mid-Year," *The Jambar* (Youngstown State University, Ohio), July 11, 1974, p. 7.

"Audrey Flack Named Visiting Professor of Art," *Bridgeport Sunday Post,* Feb. 9, 1975.

Bruner, Louise. "Brash Paintings Stimulate Thinking Rather than Passive Thoughts," *Toledo Blade,* Jan. 12, 1975, p. 4.

The Children's Blood Foundation Souvenir Journal (New York), 1975.

Cowart, Jack. "Acquisitions: Three Contemporary American Paintings," *St. Louis Art Museum Bulletin,* Sept.–Oct., 1975, pp. 88–95.

DeMarino, Marg. "Art Makes Life More Liveable," *New Haven Register,* Mar. 21, 1975.

———. "Photo-Real Paintings Newest Art Style," *Hartford Times,* Mar. 21, 1975, p. 17.

Dubrow, Marsha. "Female Assertiveness, How a Pussycat Can Learn to Be a Panther," *New York Magazine,* July 28, 1975, p. 42.

"Growing Up," *Crawdaddy,* June, 1975, pp. 42–43.

Loercher, Diane. "Soho, the New World," *Christian Science Monitor,* Oct. 15, 1975, p. 30.

"Major Art Event Painting Sold to MOMA," *New Haven Register,* Apr. 11, 1975.

McNamara, T. J. "Photo-Realist Exhibition Makes Impact," *New Zealand Herald* (Auckland), July 23, 1975.

Mikotajuk, Andrea. "American Realists at Louis K. Meisel Gallery," *Arts Magazine,* Jan., 1975, pp. 19–20.

Nemser, Cindy. "Audrey Flack, Photorealist Rebel," *Feminist Art Journal*, vol. 4, no. 3 (Fall, 1975), pp. 5–12.

"1975–1976 Cultural Programs: Photo-Realist Audrey Flack to Appear at C.S.U." *Colorado State University Bulletin*, 1975, p. 22.

Normile, James. "Contemporary Portraiture," *Architectural Digest*, July-Aug., 1975.

"Photographic Realism," *Art-Rite*, no. 9 (Spring, 1975), p. 15.

Perreault, John. "Putting His Finger in Butter," *Soho Weekly News*, Oct. 16, 1975.

"Photo-Realism Exhibit is Opening at Paine Sunday," *Oshkosh Daily Northwestern*, Apr. 17, 1975.

"Photo-Realism Flies High at Paine," *Milwaukee Journal*, May, 1975.

"Photo-Realists at Paine," *View Magazine*, Apr. 27, 1975.

Richard, Paul. "Whatever You Call It, Super-Realism Comes On with a Flash," *Washington Post*, Nov. 25, 1975, p. B1.

Toledo Museum Art Bulletin, Jan., 1975.

Weatherspoon Gallery Association Bulletin, University of North Carolina, Greensboro, 1975–76.

"The World Food Population Crisis," *Cross Talk*, vol. 4, part I (Dec.–Feb., 1975–76), p. 14.

Lanser, Fay. "Book Review—Art Talk: Conversations with 12 Women Artists," *Feminist Art Journal*, Winter, 1975–76, p. 40.

Alloway, Lawrence. "Alex Katz's Development," *Artforum*, Jan., 1976, p. 45.

———. "Art," *The Nation*, May 1, 1976, pp. 539, 541.

———. "Audrey Flack," *The Nation*, Apr., 1976.

———. "Close to Home," *The Nation*, Oct. 30, 1976, p. 446.

"At Meisel Gallery," *East Hampton* (N.Y.) *Star*, Apr. 29, 1976, sec. 11, p. 7.

Bourdon, David. "Photography Comes to Still Life," *Village Voice*, Apr. 26, 1976, p. 128.

———. "Why Photographers Like Artists," *Village Voice*, Feb. 23, 1976, p. 103.

The Bulletin Board (San Antonio), vol. 1, no. 1 (May, 1976).

Chase, Linda. "Photo-Realism: Post Modernist Illusionism," *Art International*, vol. XX, no. 3–4 (Mar.–Apr., 1976), pp. 14–27.

Female Art Show," *San Antonio Express*, Feb. 5, 1976, p. 9F.

Forgey, Benjamin. "The New Realism, Paintings Worth 1,000 Words," *Washington Star*, Nov. 30, 1976, p. G24.

Glasser, Penelope. "Aspects of Realism at Stratford," *Art Magazine* (Toronto), vol. 7, no. 28 (Summer, 1976), pp. 22–29.

Grove, Nancy. "Audrey Flack," *Arts Magazine*, June, 1976, p. 24.

Henry, Gerrit. "Audrey Flack," *ARTnews*, Summer, 1976, p. 170.

Hoelterhoff, Manuela. "Strawberry Tarts Three Feet High," *Wall Street Journal*, Apr. 21, 1976.

Jones, Nancy Scott. "Celebrating Women in Art," *San Antonio Express News*, May 23, 1976, p. 3E.

Kramer, Hilton. "The Current Backlash in the Arts," *New York Times*, May 23, 1976.

Lion Art Magazine (Taipei), Jan., 1976, p. 47.

"McNay Planning Major Exhibition," *Northside* (Tex.) *Recorder*, Feb. 5, 1976, p. 5NE.

Moorman, Adelaide. "Women's Show," *Houston Breakthrough*, vol. 1, no. 6 (June–July, 1976), p. 13.

Nemser, Cindy. "More on the Arts Backlash," *New York Times*, Letter to the Editor, May 30, 1976.

"News from the Southwest," *Women's Caucus for Art Newsletter*, Apr., 1976, p. 8.

Pension World, July, 1976, cover.

Perreault, John. "Getting Flack," *Soho Weekly News*, Apr. 22, 1976, p. 19.

———. "Photo-Shock," *Soho Weekly News*, Jan. 22, 1976, p. 16.

Perry, Art. "So Much for Reality," *Province*, Sept. 30, 1976.

"Photography: Art and Process," *Visual Dialog*, vol. 1, no. 4 (June–Aug., 1976), p. 18.

"Planning Major Art Show," *San Antonio Light*, Feb. 5, 1976, p. 5D.

Rappaport, Jody. "Audrey Flack Art in Soho," *State University of New York at Stony Brook Journal*, June, 1976.

San Antonio Express, May 21, 1976, p. 14A.

Shirey, David. "A Mark of Independence," *New York Times*, July 25, 1976, p. 16.

———. "It Was a Very Good Hundred Years," *New York Times*, Sept. 19, 1976, p. 26.

Sieberling, Dorothy. "Real Big: An Escalation of Still Lifes," *New York Magazine*, Apr. 26, 1976, pp. 42–44.

Siegel, Jeanne. "Audrey Flack's Objects," *Arts Magazine*, June, 1976, pp. 103–5.

Tucker, William G. "Louis K. Meisel: Audrey Flack," *Artists Review Art*, vol. 1, no. 4 (Apr., 1976).

———. "Sugar on the Optic Nerve," *The Villager*, Apr. 15, 1976, p. 11.

"Weekly Guide to Culture: Happenings in San Antonio," *San Antonio Express News*, May 23, 1976.

Womanschool, vol. 2, no. 2 (Fall, 1976), p. 13.

Greenwood, Mark. "Toward a Definition of Realism: Reflections on the Rothman's Exhibition," *Arts/Canada*, vol. XXIV, no. 210–11 (Dec., 1976–Jan., 1977), pp. 6–23.

Battcock, Gregory. "Dinner for Eighty," *Soho Weekly News*, Nov. 10, 1977.

Borlase, Nancy. "In Selecting a Common Domestic Object," *Sydney Morning Herald*, July 30, 1977.

Carmalt, Susan. "Huntington Displays New Trends," *Austin Daily Texan*, Aug., 1977.

"Commencement 1977," *At Cooper Union*, vol. IX, no. 2 (Spring, 1977).

Edelson, Elihu. "New Realism at Museum Arouses Mixed Feelings," *Jacksonville* (Fla.) *Journal*, Feb., 1977.

———. "Photo Realism Shows Varying Degrees," *Jacksonville* (Fla.) *Journal*, Feb. 26, 1977, p. 18.

"For the Record," *Art Gallery Magazine*, Summer, 1977, p. 80.

Glueck, Grace. "The 20th Century Artists Most Admired by Other Artists," *ARTnews*, vol. 76, no. 9 (Nov., 1977), p. 84.

Graves, Jack. "The Star Talks to Audrey Flack, Super Realist," *East Hampton* (N.Y.) *Star*, Aug. 4, 1977, p. 11.

Grishin, Sasha. "An Exciting Exhibition," *Canberra Times*, Feb. 16, 1977.

"Illusion and Reality," *This Week in Brisbane*, June, 1977.

Langer, Gertrude. "Realising Our Limitations in Grasping Reality," *Brisbane Courier Mail*, May 28, 1977.

Lynn, Elwyn. "The New Realism," *Quadrant*, Sept., 1977.

Makin, Jeffrey. "Realism from the Squad," *Melbourne Sun*, Oct. 19, 1977, p. 43.

McGrath, Sandra. "I Am Almost a Camera," *The Australian* (Brisbane), July 27, 1977.

McIntyre, Mary. "70s Art Comes to Town," *Austin American-Statesman*, Aug. 28, 1977, pp. 7, 8.

Morrison, C. L. "Strong Works," *Artforum*, Dec., 1977.

Pequod, vol. 11, no. 3 (Summer, 1977), cover.

Perreault, John. *Soho Weekly News*, Jan., 1977.

"Prints Exhibition for D'port," *Examiner* (New Zealand), Sept. 7, 1977.

Russell, John. "Photo-Realism and Related Trends," *New York Times*, Feb. 4, 1977, p. C16.

R. S. "The Museum of Modern Art," *Art in America*, Sept. 10, 1977, pp. 93–96.

"Some Artists' Ideas on Eating Well," *New York Times*, Dec. 21, 1977, p. C5.

"Spotlight," *America Illustrated* (U.S. Information Agency, Washington, D.C.), no. 247 (1977), p. 56.

Thomas, Daniel. "The Way We See Now," *The Bulletin*, Sept. 10, 1977.

Tufts, Eleanor. "The Veristic Eye," *Arts Magazine*, Dec., 1977, p. 142.

Adams, Laurie. "Intimations of Mortality," *Ms.,* May, 1978, p. 24.

Art Now Gallery Guide, vol. 8, no. 8 (Apr., 1978), p. 17.

Battcock, Gregory. "Thinking Decently: Two Audacious Artists in New York," *New York Arts Journal*, Apr. 5, 1978, pp. 24–26.

Bell, Jane. "Art About Art About Art About . . . ," *New York Arts Journal*, no. 11 (Sept.–Oct., 1978), p. 28.

Bongard, Willie. *Art Aktuell* (Cologne), Apr., 1978.

The Cooper Union Alumni Calendar (New York), 1978.

Devaney, Sally. "Kaleidoscope," *Art Gallery Magazine*, Oct.–Nov., 1978, p. 25.

Edwards, Ellen. "Eyes Have It in Portrait Show," *Miami Herald*, Jan. 8, 1978, p. 3L.

Englehardt, Nina. "Audrey Flack Portrays Man of the Year," *Women Artists News*, vol. 3, no. 8 (Feb., 1978).

Glueck, Grace. "Greater Soho—Spring Guide to Downtown Art World," *New York Times*, Mar. 31, 1978, p. C12.

———. "Soho in Springtime," *New York Times*, Mar. 31, 1978, p. C1.

Harnett, Lila. "Beyond Reality," *Cue,* Apr. 14, 1978, p. 21.

———. "Photo-Realist Prints: 1968–1978," *Cue*, Dec. 22, 1978, p. 23.

Harris, Helen. "Art and Antiques: The New Realists," *Town and Country*, Oct., 1978, pp. 242, 244, 246–47.

J. T. "Audrey Flack," *Art World*, Apr. 15–May 15, 1978, p. 13.

Jacobson, Carol. "Two Exhibits of Major Interest at Lincroft Sites," *Daily Register* (Lincroft, N. J.), Feb. 1, 1978.

Jordan, George. "Photo Realism Show at Tulane," *New Orleans Times-Picayune*, Feb. 23, 1978, sec. 1, p. 21.

Kramer, Hilton. "A Brave Attempt to Encapsulate a Decade," *New York Times*, Dec. 17, 1978, p. 39.

Lubell, Ellen. "Phototransformations," *Soho Weekly News*, Sept. 28, 1978, p. 80.

Mackie, Alwynne. "New Realism and the Photographic Look," *American Art Review,* Nov., 1978, pp. 72–79, 132–34.

"Man of the Year," *Time*, Jan. 1, 1978, cover.

The New Republic, June 24, 1978, cover.

O'Conor, Mary. "Eight Artists," *East Hampton* (N.Y.) *Star*, July 17, 1978, p. 14.

Perreault, John. "Audrey Flack, Odds Against the House," *Soho Weekly News*, vol. 5, no. 25 (Mar. 23–29, 1978), pp. 19–21, cover.

———. "A Painting that Is Difficult to Forget," *ARTnews*, Apr., 1978, pp. 150–51.

———. "Photo Realist Principles," *American Art Review*, Nov., 1978, pp. 108–11, 141.

"Photo Journalism and Photo Realism," *Milwaukee Journal*, Dec. 10, 1978.

Raynor, Vivien. "Audrey Flack," *New York Times*, Apr. 14, 1978, p. C22.

Richard, Paul. "New Smithsonian Art: From 'The Sublime' to Photo Realism," *Washington Post*, Nov. 30, 1978, p. G21.

"Segunda Guerra Mundial," *Artes Visuales*, no. 18 (Summer, 1978).

Shirey, David. "Drawings: A Show with More than One Meaning," *New York Times*, Feb. 5, 1978, p. NJ–19.

———. "More Real Than Real," *New York Times*, Aug. 6, 1978, p. L1–14.

"Special from Broadway," *East Hampton* (N.Y.) *Star*, July 20, 1978, p. 13.

"Style Hampton-Style," *East Hampton* (N.Y.) *Summer Sun*, July 27, 1978, p. 11.

Thill, Mary. "Photorealist Flack Visits Brookdale," *The Stall* (Brookdale, N.J.), vol. 17, no. 2 (Feb. 17, 1978), p. 5.

Goodman, Vera. "Surprise Them with Art," *New Directions for*

Women (Westwood, N.J.), vol. 7, no. 4 (Winter, 1978–79), pp. 13, 22.

"American Painting of the Seventies," *Bulletin*, Krannert Art Museum, University of Illinois, vol. 5, no. 1 (1979), pp. 2–3, 5.

Melcher, Victoria Kirsch. "Vigorous Currents in Realism Make Up Group Show at UMKC," *Kansas City Star* (Mo.), Mar. 11, 1979, p. 3E.

Perreault, John. "New Life for the Still Life," *Soho Weekly News*, Apr. 12, 1979, p. 54.

———. "New Museum? For Real? It Figures," *Soho Weekly News*, Sept. 20, 1979, p. 43.

Sozanski, Edward. "Narratives Boldly Stated Preface Untold Stories," *Providence Sunday Journal* (R.I.), Aug. 19, 1979, p. H1.

"Statues Don't Hit Back," *New York Times*, Feb. 16, 1979, p. C23.

Weintraub, Linda. "Perspective '78: Works by Women," *Arts Exchange* (Philadelphia), vol. 3, no. 1 (Jan.–Feb., 1979), p. 25.

"What's On in Washington," *Women Artists News*, Jan., 1979, p. 2.

BOOKS

Coke, Van Deren. *The Painter and the Photograph.* Albuquerque: University of New Mexico Press, 1972.

Kultermann, Udo. *New Realism.* New York: New York Graphic Society, 1972.

Kortlander, William. *Painting with Acrylics.* New York: Van Nostrand Reinhold, 1973.

Sager, Peter. *Neue Formen des Realismus.* Cologne: Verlag M. DuMont Schauberg, 1973.

Who's Who in American Art. New York: R. R. Bowker, 1973.

Kamarck, Edward, ed. *Arts in Society: Women and the Arts.* Madison, Wis.: University of Wisconsin Extension, 1974.

Art—A Woman's Sensibility: The Collected Works and Writings of Women Artists. Valencia, Calif.: California Institute of the Arts, 1975.

Battcock, Gregory, ed. *Super Realism, A Critical Anthology.* New York: E. P. Dutton, 1975.

Chase, Linda. *Hyperréalisme.* New York: Rizzoli, 1975.

Kultermann, Udo. *Neue Formen des Bildes.* Tübingen, West Germany: Verlag Ernst Wasmuth, 1975.

Nemser, Cindy. *Art Talk.* New York: Scribner's, 1975.

Pomeroy, Ralph. *The Ice Cream Connection.* London: Paddington Press, 1975.

Rose, Barbara, ed. *Readings in American Art, 1900–1975.* New York: Praeger, 1975.

Petersen, Karen, and Wilson, J. J. *Women Artists.* New York: Harper & Row, 1976.

Who's Who in American Art. New York: R. R. Bowker, 1976.

Melville, Keith. *Marriage and Family Today.* New York: Random House, 1977.

Rose, Barbara (with Jules D. Prown). *American Painting.* New York: Skira, Rizzoli, 1977.

Selleck, Jack. *Faces.* Worcester, Mass.: Davis Publications, 1977.

Lipman, Jean, and Marshall, Richard. *Art About Art.* New York: E. P. Dutton, 1978.

Saff, Donald, and Sacilotto, Deli. *Printmaking.* New York: Holt, Rinehart and Winston, 1978.

Walters, Margaret. *The Nude Male: A New Perspective.* New York: Paddington Press, 1978.

Chaet, Bernard. *Artist's Notebook: Techniques and Materials.* New York: Holt, Rinehart and Winston, 1979.

Lucie-Smith, Edward. *Super Realism.* Oxford: Phaidon, 1979.

Saff, Donald, and Sacilotto, Deli. *Screenprinting History and Process.* New York: Holt, Rinehart and Winston, 1979.

Seeman, Helene Zucker, and Siegfried, Alanna. *SoHo.* New York: Neal-Schuman, 1979.

Meisel, Louis K. *Photo-Realism.* New York: Harry N. Abrams, Inc., 1980.

Acknowledgments

The strong belief of Margaret Kaplan and Hugh Levin at Harry N. Abrams, Inc., that books written by artists are of great value brought me to write this book. I particularly wish to thank them for their encouragement and support.

Also, I wish to thank Jeanne Hamilton for her friendship and sensitive vision, and my assistant, Carol Benson, who researched and typed the manuscript, for her dedication and acumen.

Beatrice Gilman Proske, curator at the Hispanic Museum in New York City for many of the fifty years she has been there, has done extensive research on Luisa Roldán. I have relied heavily on that research. An article by Ms. Proske about Luisa Roldan can be found in *Connoisseur,* Feb.–Apr., 1964.

And, of course, my special appreciation to Bob Marcus for his calm and steady presence and invaluable assistance through all phases of the preparation of this book.